Olson's
Gloucester

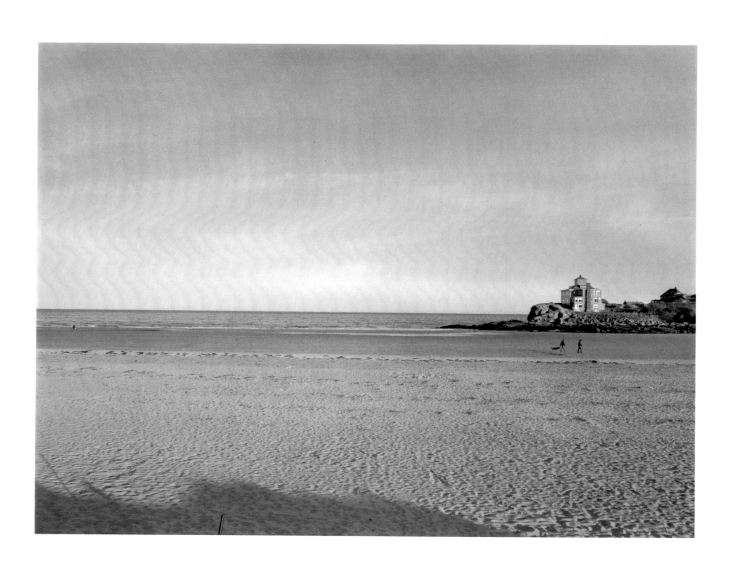

Olson's Gloucester

PHOTOGRAPHS BY
LYNN SWIGART

*An Interview with Lynn Swigart
by Sherman Paul*

Foreword by George Butterick

LOUISIANA STATE UNIVERSITY PRESS
Baton Rouge and London

DESIGNER: Joanna Hill
TYPEFACE: VIP Trump Medieval
TYPESETTER: LSU Press
PRINTER: Hart Graphics
BINDER: Universal Bookbindery

LIBRARY OF CONGRESS CATALOGING IN PUBLICATION DATA

Swigart, Lynn, 1930–
 Olson's Gloucester.

 1. Olson, Charles, 1910–1970—Homes and haunts—
Massachusetts—Gloucester—Pictorial works. 2. Gloucester,
Mass.—Description—Views. I. Title.
PS3529.L655Z86 811'.54 [B] 80–15124
ISBN 0–8071–0765–4 (cloth)
ISBN 0–8071–0791–3 (paper)

For Joan

Contents

Foreword

Lynn Swigart came to the Atlantic coast with no doubt a lingering, genetic memory of the sea. He was born well within that once vast vestigial ocean now the Great Plains, in Kansas City, Missouri, in 1930, and raised in Clinton, Illinois, attending Bradley University in nearby Peoria. He has remained in Peoria, serving the Caterpillar Tractor Company—that symbol of hard work and American enterprise—for almost twenty-five years, as manager of publications. For the same twenty-five years he has held a life aside, deliberately, determinedly, as an independent photographer, exhibiting regularly since 1970 and with work in many museum collections. The photographs herein are a result of a succession of visits to Cape Ann, Massachusetts, his curiosity having been stirred by the enthusiasms of his friend Sherman Paul, the noted Americanist, then deeply immersed in his own work on the writings of Charles Olson, published as *Olson's Push*. Swigart came to Gloucester first in the fall of 1976, then in every season, obeying the spirit of the place and the work of the man whose poems so thoroughly embody it.

Charles Olson has come to be regarded since his death in 1970 as a major shaper of postmodern American poetry, the chief successor to Ezra Pound and William Carlos Williams. His place in literary history is assured by such achievements as his epic series *The Maximus Poems* and his theoretical manifesto "Projective Verse," as well as by his acknowledged influence on an entire generation of poets. He was the central voice of the so-called Black Mountain Poets, a group including Robert Creeley and Robert Duncan and deriving its name from the poets' association with Black Mountain College, well known for its contribution to the arts.

Olson's major work, *The Maximus Poems*, in three volumes, is focused on the city of Gloucester, Massachusetts, which serves as a microcosm to the larger America. Although born in Worcester in 1910, most of the poet's happiest and most significant memories were of Gloucester, where he summered with his family. Following the close of Black Mountain College, he returned to live in Gloucester, among the fishermen of Fort Square in a second-story cold-water flat overlooking the harbor.

On the coast thirty miles northeast of Boston, Gloucester was in the nineteenth century one of the leading fishing ports of the world. Today, although fish is still processed, tourism is the leading industry. The city, which celebrated the 350th anniversary of its founding in 1973, is on Cape Ann, an area of great natural beauty and variety, home of the intrepid fishermen Olson grew up among and admired, daily pitting their lives against the full North Atlantic. It was home or visiting place, too, for artists such as Fitz Hugh Lane, Winslow Homer, Marsden Hartley, and Stuart Davis, who painted it in a variety of styles. Its landscape figures prominently in *The Maximus Poems* and is given, in turn, a mythic dimension by

them, from its coves and promontories to Dogtown, now tumbled cellar holes of a deserted village on a ghostly moor in the center of the Cape. In Dogtown, for instance, the Primeval Hill of all Creation arises or one can find the mouth of Hell. Figures from the historic past merge with those from myth, the still further past. Olson considered himself as much a historian as poet, and his sense of history—which was thoroughly Herodotean, 'to find out for oneself' —was inseparable from geography. He embraced Alexander Von Humboldt's observation that "In classical antiquity the earliest historians made little attempt to separate the description of lands from the narration of events. . . . For a long time physical geography and history appear attractively intermingled." The definition of landscape as that "portion of land which the eye can comprehend in a single view" dominates the later poems (and infuses many of Lynn Swigart's photographs of Gloucester as well).

What made Gloucester a model or source of possibility for Olson was that he conceived of it as actually an island in the Atlantic, separated from the mainland (and mainland culture) by the Annisquam River, a tidal estuary that connects Gloucester Harbor with Ipswich Bay in the north. Until the mid-sixties its regular population (not counting the summer influx) had remained the same for nearly seventy years. It is now all changed, of course; there has been urban renewal, as in most of our older cities, even the smaller ones, and its streets are as choked with automobiles as the road to Hell. But what Olson was able to offer was an image of a city, a *polis*, a sacred *temenos*, in his words a "redeemable flower that will be a monstrance forever, of not a city but City." He writes among his notes: "The interest is not in the local at all as such—any local; & the choice of Gloucester is particular—that is the point of the interest, particu-

larism itself: to reveal it, in all possible ways and force, against the 'loss' of value of the universal." For the poet, Gloucester is the twentieth-century analogue to the Phoenician city of Tyre, which was the last holdout against Alexander the Great's conquest of the known world, what Olson calls the "universalization" of the world. Tyre was captured only after Alexander laid siege to the city and constructed a causeway or mole, comparable to the present highway Route 128, completed in 1959 during the course of the poems, which encircles Boston and ends in Gloucester, bringing with it mainland values or the corruption of true value.

Olson explored Gloucester as a historian and archeologist ("archeologist of morning," he called himself) rather than as a sociologist. He knew every corner and rock pool, talked himself into each cranny. He sought to restore to America its "city on a hill," built out of sound like Amphion's Thebes by the power of poetry alone; a city that would shine as its name says it should: Gloucester was once Glaow-ceastre, the Glowing City. In Lynn Swigart's photographs there is evidence again to believe this.

Swigart came to Gloucester with his eyes alone, without a head full of the written histories and tourist guides jostling for attention; straight from the prairie sea with only lines from *Maximus* and an open curiosity to guide him. The resulting photographs are in no sense a documentary of the poems or even of the place, but of the encounter —one man, one place; two alert eyes, one focus extended. There is a sense of not pose but poise, of calming or charming the landscape until it settles at his feet, a peaceable kingdom of forms. The targeted area yields itself for him, rewards such meticulous attention with favors, some secrets. Some gull-man at work, who goes by instinct, who *commands* a view. Some in-

stinctive power over the setting, to make the scene (that which was, indeed, *seen*) obey his will without appearing compelled, contrived, or stiffly framed. All are earned; there are no "cheap shots"; luck didn't have anything to do with it. These are photographs of insight, in which sight is a condition of being, a state of being *in* sight (he renders the familiar anew). The work is unposed, as he accepts the poet's own principle of history as self-discovery. He does not rudely challenge the landscape or impose himself upon the city; there is no chill eye and ruthless opportunism. Instead there is the reverence of a newcomer who has heard tales, lovingly passed on, about a place of singular value. He has no "statement" to make at the expense of what lies before him and goes about its existence regardless of whether he ever came with his equipment and his personality. His scenes have their absorbing, cumulative moment, which he encompasses without encumbering it with his own preconceptions. He is neither aloof nor deigning nor designing. Each photograph is a patient and deliberate act of possession, reflecting the photographer's own self-possession. It is a holistic relationship of art with place.

At times it would seem Gloucester was as impressed with her visitor and his glinting lens as he with her. Mists and sea spray come to earth, so that we pass through, we feel them on our cheeks, in our hair lighter than fingers. There is that palpable reality to these photographs. His Ten Pound Island in Gloucester Harbor has all the luminosity through swirled mist that the painter Fitz Hugh Lane is celebrated for, painting the same scenes more than a hundred years earlier. There is the natural setting, which predominates: the skies and multiple airs of Cape Ann, the cleansing sea, the blunt rock brows of the eccentric New England headlands. Or his cap-

turing of Ten Pound Island from the Stage Fort shore, with swell of rock in the foreground like the sea itself caught in pause, in homage, before the island in its own repose and singularity to which we too attend. There are also the evidences of man—the fresh streets with the eighteenth- and nineteenth-century wooden houses dazzling in the aroused morning or cast darker in the lee shore of a day; an isolated Victorian guesthouse greets day across salt marshes and stretch of beach. Occasionally, some little badinage with the inhabitants (including early morning dogs) is al-lowed. His panoramic view of the city, spread at length across the harbor, passes progressively from the heights of the Stage Fort bluff through the shapely arms of Half Moon Beach. There is a permanence to the setting, a persistence in the view that is also the spirit of the place. The repeated visits, the repeated acts of attention, appear as a single and continuous act of love.

GEORGE F. BUTTERICK
January, 1980

Acknowledgments

Tom and Joan Hunter spent many hours acquainting me with Cape Ann and its maze of roads and lanes. Linda Parker, hiker and camper, shared her more intimate knowledge of the less accessible spots, including Dogtown. She and Fred Buck also gave openly and warmly of their companionship and hospitality throughout the project.

Finally, I'm deeply appreciative of the sensitivity, creativity, and dedication that Joanna Hill combined so skillfully in her design of the book.

Olson's
Gloucester

Interview

WITH LYNN SWIGART
BY SHERMAN PAUL

SP As I recall, this project began in the Barn in Dubuque in April of 1976 where your gallery talk confirmed for me the quality of your work in respect to landscape and light, and suggested the idea I then proposed—that you photograph Gloucester, Olson's Gloucester. I suppose a question anyone would like to have answered is how you went about photographing Gloucester? How do you go about photographing a city? And maybe another question to go along with these is what is your motive when you do it? Is it to conserve the past? Is it to give us a visible history of the city? Is it nostalgic? Is it elegiac? So many photographers are concerned with the vanishing present. What motive, or motives, did you have when you went about it? How did you finally decide that this is the way it had to be done?

1

LS Well, I first went to Gloucester to survey the extent of the commitment I'd made, and I think it was only then that I appreciated that I didn't have an intellectual framework in which to approach Gloucester. When you are taking random photographs or photographing an incident, say a street fair or a person, your framework is defined for you by time or by an event. You're out for the afternoon photographing, and you photograph whatever you encounter. Or you're in a new place doing something casual. But suddenly to be confronted with Cape Ann, less Rockport, which is what Gloucester is and not just the town proper! That really is formidable. For then I had to decide whether the task was historical, and it was pretty easy to dispose of that because it was much too sizable a task to document everything that was important or to document everything that the Chamber of Commerce thinks is important, or the Historical Society, or the artists' colony.

The countervailing thing in all this was the tie with Olson's work. The other decision I had to make was how to tie to that, and after reading Olson's work—and rereading much of it, trying to become comfortable with it—it seemed clear to me that it's not the kind of poetry that one would attempt to *illustrate*, and least of all would I attempt to illustrate his poems or anybody else's. I don't like that kind of photography. But there are dominant landscape features that he treats—such as Ten Pound Island and the Cut and Dogtown. And they are important to Gloucester. You'd almost have to be blind not to stumble across them. Some of them posed difficult photographic problems. And this brings us to a real difference between photography and, let's say, poetry. Photography deals in a flat plane both visually and in time, and there's no way to sketch in as a preface to a photograph what Gloucester used to look like. You can't go back as Olson did historically or geologically. In a photograph you're really tied to now. That limits what a photographer can do as against what a poet can do. So I rejected the bald, straightforward documentary as impossible from a time and an interest standpoint, and I rejected as inappropriate illustrating any of the poetry or writing of Olson. I went to Gloucester six or seven times during the course of two years, in all seasons. I tried to immerse myself in the *Maximus* poems and other works of Olson to have that background and to open myself to Gloucester. I went about at all times of the day, in as many circumstances and as many seasons as I could, in order to come to know it better. I took many photographs, but the ones that have been exhibited are the ones that appealed to my visual sensitivity. Some of the subjects, such as Ten Pound Island or the marsh—

SP Yes, those are especially fine, and they lead me to ask about the mythic dimension of your work. One of the things that's so impressive in Olson's work is the sense he evokes of the presence, the actual presence of the creative agencies for which myth is an account. In his work, Dogtown is still in the process of emerging from the sea, and the same gods and goddesses are still present in the world. Does your approach summon that dimension of Olson's work? Do you think that the Ten Pound Island picture renders that dimension, is the center of the golden lotus? For Olson it sits there in the harbor and finally becomes in the last book of the *Maximus* the geographical equivalent of the center of the mandala, or the golden lotus itself. It seems to me that in that picture, even though it's absolutely faithful to the cloud that's rushing down on the island, you've happened, through the good agencies of chance and preparation, too, to catch it in a luminescent way. Not like nineteenth-

century luminism. Not like Fitz Hugh Lane. There's nothing of Fitz Hugh Lane for all of his luminism that ever gets that quality of light, that epiphanic quality. For me, it comes very close to the spirit of Volume 3 of *Maximus*.

LS Ten Pound Island is a special case. We should talk about it, because it was dominant in Olson's writing. Of course, he lived near it. I tried to photograph it and worked at it from water level down by the paint company which is out on a point very near it and from Governor's Hill in Gloucester, as high as you can get. The problem with Ten Pound is that it is a very low rocky island; it's probably not twenty feet above the ocean at low tide. It merges visually with everything. No matter where you are— eastern shore, over at Stage Fort—it merges with the background and you can barely find it. I tried in every way to isolate it, and couldn't make anything out of it.

SP You couldn't make it into what Olson apprehended it to be? His vision of it?

LS That's right. But he looked at it binocularly, which helps to isolate anything, and he looked at it in all seasons. He saw it with snow blowing around it; he saw it at night, and with ships coming around it; and I'm sure he saw it differently in his mind than he saw it visually. It began to assume importance. I had the problem of not being able to make anything out of it; I was completely frustrated. Then on one of the later trips when I was working in Stage Fort— it was April, bitter, damp cold, as it can be on the ocean, and everything that was metal was hurting my hands, and it was raw and windy and the focusing cloth was flapping. I was photographing rocks and looking towards Dogbar breakwater, and suddenly here was

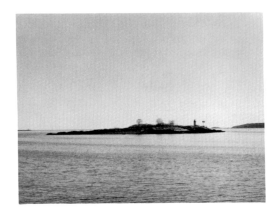

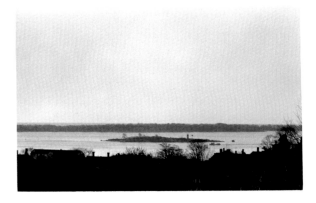

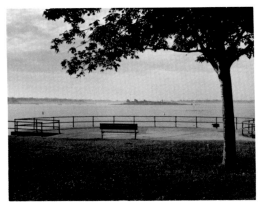

3

this fog cloud right at ocean level, blowing down on Ten Pound. I repositioned everything, which is not so quickly done when you are working with a big camera, got everything reset, and had maybe ten or fifteen seconds to get two photographs as the cloud blew behind Ten Pound isolating it from the eastern shore. That's really serendipity, plus the fact that I had put myself near Ten Pound many times and was trying to find the right time to photograph it, knowing that I didn't have what I wanted. And I didn't know what I wanted until I got it and discovered that it had the sort of mythical quality, as you put it, that Olson speaks about. It's partly selection. I could have selected any of the Ten Pound photographs. I selected this one because I think it is the best one, and it shows Ten Pound most nearly as Olson seemed to perceive it. But, you know, it wasn't contrived.

SP One of the things that interests me is that you take a number of images and that this is a composite work with a serial character. Any single image is to be seen—is inevitably seen—in the context of the total sequence or series. Is there a sequence in which these images should be ordered? What is the incremental value of the series? Does the serial aspect, this context, enable you to achieve as a landscape photographer what Olson achieved as a landscape poet? The great achievement of Olson as a landscapist is to have avoided the spectatorial, or outside-vantage viewing of the landscape. He centered himself within the landscape and presented the landscape not in a single view but in a series, or with multiple perspectives from his center. Now, does your series achieve that same sense of location, so that it could be said that the imaginary vantage point from which all the photographs were taken was somewhere in the center or within the landscape of Gloucester? that finally you were not

outside it? that by doing this work you had entered the landscape just as Olson entered the landscape, and that the total series then would give you the total landscape and the sense of circumambiance?

LS I think so. That is the culmination of many individual images. Some of Olson's work is the culmination of individual examinations of a particular place over a period of time, but all of it derives from a constancy of point of view. I tried to perseverate a point of view, with modulation, for Gloucester in the two years that I worked there. One of the joys of this project, and one I had not experienced before, is its long term. You grow with it, and so there is this modulation, this change, but still I had to be true I couldn't change my basic course or I would have destroyed some of the earlier work, and I think I would have visually confused the whole thing. So I had to remember how I was approaching it, keeping that in mind throughout. From a practical standpoint both in deriving a better set of photographs and in maturing your ability, a long-term project gives you the opportunity to go back to re-do, to re-do perhaps because you've failed the first time to achieve what you wanted, maybe technically, or you know another time of year, another kind of light, another kind of climatic condition would give you a better opportunity at the same place. These are opportunities that you usually don't have or don't take; you don't create the luxury of doing this in most photography. It's a sort of one-shot deal. You're some place and you photograph it, and if you're there in the afternoon and it's sunny—fine! But you don't go back there months later on an overcast day when it would be perfect. I had that opportunity because of the number of times I visited Gloucester.

4

That raises the question: Is it better to be a visual stranger to a place in order to photograph it or to be a native and be familiar with it? If you're visually perceptive and come into a new place everything is a revelation to you, and you're able to examine freshly everything from the most mundane to the most spectacular. You take them all at face value, and I think you discover a lot of things that have become invisible to the native. They see them every day and so they don't see them at all. It's much more difficult, even for those of us who are used to looking all the time, to see our own neighborhood in a fresh way. That really is work. On the other hand, being a stranger you undoubtedly miss some things. You just don't know they are there, and you never learn they are there. From a practical viewpoint, you waste a lot of time. You get lost, you don't know how to get places, you think you can get someplace by sunrise and find you're ten minutes too late because you didn't know how to find the place. All those things, the difficulty of not being familiar with an area—and Gloucester, small as it is, is a honeycomb of roads that people have to tell you about; the signs say Private or Keep Out, but the natives can go there all the time—you have to learn all those things or you can't even find the real city. And, you know, in the evaluation and trade off, even with the practical difficulties it was better for me to come into the place as a stranger. Everything was a revelation to me.

SP Do you think you found some things that Olson didn't see?

LS I did quite a bit of work with the people because that appealed to me. He mentions people—mostly historical. There are not many contemporary people mentioned in *Maximus*.

SP Ferrini, Helen Stein, people like that. Friends. He mentions the Portuguese fishermen, but I don't think he dwells as your images do on that festival, the Italian community . . .

LS Right, the Mother of Grace . . .

SP I've always been struck in your work by the combination of concern for landscape and for people.

LS It's not a dichotomy. It's unfortunate when people ask, Is he a landscape photographer, a street photographer, or a portrait photographer, because that's limiting. You can move from one to the other, and I have. Both place and people are important elements of Gloucester in my view. The people were magnificent all the time I was there. There's something about living there . . . it's very attractive, and people drift there on a vacation or by chance and come back to live. The working people there are incredibly vital because they are still doing something real. The fishermen, the carpenters—it's a good working town. It has a summer art colony, but that doesn't dominate the town. Such a good working town was too strong and too rich for me to pass up. And the people, all the time I was photographing, no matter how intimately I photographed them, not rudely, but intimately, were very kind, very considerate, never hostile, lovely in their reception, and so I responded very positively to them.

SP I've been rereading Susan Sontag's *On Photography*, attending especially to what she says about landscape, which is something she almost omits as if all the profound questions and most provocative things she has to say about photography somehow don't apply.

LS Well, its really hard to make a photographer an aggressor towards the landscape as much as he is towards human subjects. She is concerned with the acquisitive, aggressive nature of photography, a theme, incidentally, we don't all agree with.

SP Yes. You've talked about your interest in people, but how did you come to this concern for landscape? You know, having done this project, you've confirmed your importance as a landscapist. From Olson's point of view, anything so geographical, that has geography at it's center, would confirm you as a landscapist. He would call you an "areal" artist after Carl Sauer's definition. You're concerned with topography and light—the perfect bowl of the sea and the land. How did you come to landscape?

LS I don't know. I've been taking landscapes since I was in high school. I grew up in Illinois, and it's not a spectacular landscape so you learn to look carefully and to appreciate subtleties.

SP You were telling about how you went about photographing Gloucester. Does this prompt you to want to arrange the photographs chronologically? Is that the best way to arrange them, so we appreciate the nature of your entrance into the Gloucester landscape? Or should they be arranged by sequences of certains kinds of images? Would that be the best way? Is there a preferred way to arrange these materials?

LS If you arrange them chronologically, you should arrange the work prints and not the final prints. That would tell the long story of my entry into Gloucester. It becomes refined because some things you photograph you find you don't care about, some things you want to go back and rephotograph, and

then you pick up new things. After you've been there three or four times and spent a number of weeks there, the dominant things have been dealt with mostly, and you begin either to go back to things that you haven't dealt with in the way you want to or to find the less prominent features. You would see this in a chronology, but I don't think that's the way in which to look at the body of work.

Every time we hang the show we change the sequence because it depends on the gallery space, the shape of the gallery, the lighting, the entrances. Some works, of course, inevitably go together. I've tended, for instance, to hang the pictures of Our Lady of Good Voyage together because they relate to each other. We've used three in the book, including the photograph of the big cake made in the image of the church. Together they give a fuller picture of the church. Other things may be put together sometimes because one of them has a lot of power towards the left, let's say, and maybe it belongs on the right end of a group of photographs because it holds the wall together or it works into some other images. You relate photographs in a gallery to the dynamics of the space you're in.

With books it's very difficult. In books you look at one or two photographs at a time. If there is a single photograph to a page, you have a summing effect but it depends on the memory of the viewer. You can't step back to look at ten or twelve and to see how they fit together in tone value or subject and then narrow in on some you want to examine and move to the right or left. A book isn't like that. There's a different problem in sequencing.

SP If the context matters so much, how would the context of an exhibition in Gloucester or the publication of these pictures in the *Maximus* poems

alter what we see? Wouldn't an exhibition of these Gloucester pictures in Gloucester itself be an additional context in which to see them? You're in the very place. And don't we, as Susan Sontag says, begin to see a place in terms of the photographs of the place? measure the reality and the very features of the place in terms of what the photographer has done? Do you think that in the future people will see Gloucester in terms of the images you produced? One of the inevitable outcomes of such a body of work is that you have created Swigart's Gloucester, and it will become the touchstone by which we test the reality of the actual physical environment that originally inspired the photographs. No one hereafter will ever see Gloucester without some awareness of that; that will do away with the innocent eye. That's certainly true for me. All of the pictures in the Memorial Catalog of painters of Gloucester* and of the pictures by Fitz Hugh Lane have become part of my viewing of the landscape. . . . What if we put them in the *Maximus* poems?

LS I don't know that they belong there. I'm not sure that would be a service.

SP But sometimes when you exhibited these photographs, there were on the walls of the museum selections from Olson's poetry, especially pertinent landscape poems.

LS One would think that I had illustrated some of those passages. I had not seen them; George Butterick picked the passages, and I thought the coincidence was remarkable. But some aspects of Gloucester are

* *Portrait of a Place: Some American Landscape Painters in Gloucester*

so strong and so recurrent they are always going to be noticed by artists, as Lane noticed them, as Olson did.

SP Still, you avoided the motifs of the artists' colony. I don't find any of that. You enable us to clear our minds of the art-scene Gloucester, which is the first Gloucester that most of us know.

LS That's the boat turned over at low tide . . .

SP That's what Olson did too. There is very little of that in the entire body of his work. He knows who Marsden Hartley is, but there is very little of the tourist Gloucester. What about the ships? I remember some photographs of ships. Do you think you've given enough attention to the economic, or fishing, aspect of Gloucester?

LS No, I don't think so. I think there are many inadequacies if you are looking for some kind of straight-line representation.

SP You said you had been photographing since high school . . .

LS That was seriously. I started photographing when I was seven, a classic case of starting with a baby brownie. Then I met an older boy who had a darkroom and experienced the revelation of images coming up. From that time on I have been involved in photography. When I was first married, I had a studio, in a small town, Clinton, Illinois. Briefly. That was back in the fifties, and it was apparent even then that you couldn't make a living doing it. Television and instant photography and a general disinterest in portraits were killing all of that. So in a year and a half, I got out of it. And I'm glad that I didn't stay in com-

mercial photography because then you can't pursue it as an art form; there are too many economic and time constraints.

SP What makes it an art form?

LS That's contentious, isn't it?

SP I know, but Susan Sontag argues that any photograph taken by anyone with any kind of equipment is as good; there's no real way to evaluate it because it's the content of the photograph that is finally preemptive and interesting. So that the so-called artistic value of a photograph is not the most important thing, or very hard to determine. But it's evident to me that there is such artistic value when I look at your pictures. Could you say what it is that transforms them into art objects?

LS You can attack that from the object itself; that is, whether the photograph is satisfying, adds something to the viewer's life, is stimulating or pleasant or mysterious—something besides just a banal image. The end result has to be part of the measure of the worth of something, in spite of all the conceptual theories and all the student talk about whatever comes out, if that's what you want, it's all right. There is an objective measure of the quality of work. It's partly technical; it's partly a matter of vision. How did you frame it, at what instant in time did you take the photograph, what time of day, what time of year?

SP At what time do you like to work?

LS I like low light for many things. You'll find a variety of lighting in the Gloucester photographs.

The least favorable light, contrary to the old folklore, and this is not news anymore, is midday. Bright overhead sunlight is very hard to deal with because the shadows are harsh and sometimes obstruct landscapes and cityscapes and are very troublesome on faces. So I like low light. Much of the time I worked early in the morning which is usually better than late at night, because there is less traffic and the atmosphere is a little cleaner before a whole day of smoke, exhaust, smog. I like overcast days because you get that very even quality of light that allows you to deal with the textures of rocks and sand. And you know the texture itself is enough. To have the texture plus an enormous amount of shadow from harsh light completely changes some of those things, makes rocks extremely difficult to photograph.

But to go back to the question of art form. It's hard to distinguish art and craft to some extent, and it's not just in photography that we have this problem. You make aesthetic decisions when you take a photograph, and you make others in making prints. An understated truth is the similarity between photography and etching or lithography.

SP But not painting.

LS Printmaking. They are multiples to start with. There's an enormous amount of control, I don't mean contrived control, but there are many decisions made when the print is made. I really feel that I am a printmaker. I like to make prints. There's an awful lot of nonsense about the drudgery of darkroom work and the joy of field work. Well, taking pictures is a joy, but so is printmaking, in my view. If you don't approach it in that way, you probably won't make fine prints. And there are decisions to be made. Not the nineteenth-

century decisions of contriving things, doing montages, putting clouds in where they weren't, but decisions concerning the luminosity of the photograph, the contrast range, and what to include, though basically you tend to use the entire negative. These things determine what the final print's going to look like. There is an enormous amount of work; some very hard decisions are made in the printmaking process. An etcher has similar options in preparing the plate. It's not just pushing a button and coming up with a picture, and I think Sontag betrays some lack of knowledge of the process in her conclusions.

SP You use the word *project* in respect to photography—project photography. Would you explain?

LS In casting about for a way to characterize Olson's Gloucester, the body of work I had done, I couldn't think of a better name than *project*. It was set for me, or I set it for myself, as a definite thing to do, a project. It had a beginning, and although it's open-ended, it had to be finished—much of it—to meet commitments at the University of Connecticut and at the University of Iowa. And it had a geographic boundary. I didn't take anything that wasn't in Gloucester. I was very careful about that boundary, because I wanted to be faithful to the description, Olson's Gloucester.

Project also covers the fact that I spent sustained periods at the same site, and was able to live with my work, refine or redefine an image, go back and do it in a different way, go to the same place and try to capture something with more clarity or more impact. Technically it was a learning experience. It's like photographing the same subject over and over again, as Steichen did with the china when he perfected his

use of lighting. You work on something that is itself fairly stable, and you can measure your own progress. If you always work on different subjects, it's hard to have a benchmark for developments in your ability.

SP This is also one of the enabling aspects of coming into a sense of place. Unless you frequent the same space many times it will never become place.

LS I have never had the resources or the motive to know a place. I don't know the history of where I was born or where I live now nearly as extensively as I know the history of Gloucester. The places where I have lived have never been covered as well. We don't have a Joe Garland, for instance, who did *The Gloucester Guide*. It's invaluable. Nobody has done that for Peoria. Frequently, you just go photograph something —react to it visually, completely superficially in that sense.

SP Yes, but it's a visual dimension . . .

LS But you don't know anything about what went before, what comes afterwards. You photograph it and go on. And maybe, those photographs look exactly like ones taken when you know a lot more about it. Obviously there's still only a two-dimensional image —or one-dimensional image, but . . .

SP Are there any precedents in the works of other photographers for what you did?

LS Yes, many. I think of Strand's work. If you think of some of the places he went, Tir A Mhurain, for instance, or Egypt. Those were projects. Steichen, again, when he was older did that marvelous series of

the tree that grew on his estate. And there's a lot of current interest in project photography—it's ability to encompass, amplify and preserve.

SP "Equivalents" by Stieglitz.

LS Yes, in a different sense I think.

SP And Sinsabaugh's Chicago Landscapes. Where would you place your work in the traditions of American photography? With whom should we associate you? With the pictorialists? With the straight photographers?

LS That's hard for someone to answer for himself. I identify with the straight photographers. Whatever that means, that's where I identify. I mean, we all bring a lot of our own personality . . .

SP You're not trying to be painterly.

LS Not at all . . .

SP You're not using soft focus. I can't think of anything of yours that is in soft focus.

LS I hope not. No, that's right, or S curves or a set of triangles, or fixed rules of composition.

SP What you say about the craft suggests that you're in the straight group that's concerned with good lighting, clarity of image.

LS I think that's where I am.

SP How do you think Olson would have responded to these photographs? Would he have put you in the tradition that moves through Lane and Olson?

LS I don't recall how he responded to Lane. It wasn't all that positively, was it?

SP Well, let's look at the poem called "An Enthusiasm," in which he talks about what Lane didn't do, but in this he places him among his New England contemporaries, Parkman, Prescott, Noah Webster, and then at the end he says, "He was one of the / chief definers of the American 'practice'—the word is / Charles Pierce's for pragmatism—which is still the con-"—he breaks it there—"spicuous difference of American from any other past or any / other present, no matter how much we are now almost / the true international to which all bow and acknowledge." And the word there—of course there are three words—*practice, pragmatism* and the way he uses *conspicuous*, which is the Latin for seeing, carefully seeing—and to answer my own question, it seems to me that he would have responded to the *conspicuous* aspect of the work, the clarity of vision, the attention with which you've seen, the fact that in the serial nature of the work you have put yourself in the field, within the field. And then I don't know how he would have responded—I'm sure he would have appreciated the Ten Pound Island photograph and some of the others—but he might have felt—since he has his own mythical landscapes in which he populates the landscape of Gloucester with deities, especially the maternal deities, the goddess Aphrodite—he might have felt that somehow photography can't capture the sense of mythic presence, that maybe only language, maybe language or some other form can do that. Painting could do it, but one wonders about photography. Harry Callahan captures the maternal archetype in the Eleanor photographs, so I suppose it can be done. There's a poem where Olson wrestles with the maternal figure in the sea. He wants to draw her up from the

sea. Now that would be very hard for you to find a visual equivalent for. Does he talk about any photographer?

LS No. The only photograph that I know of him talking about is the snapshot of his father at the Whale's Jaw.

SP Yes. But he might have remarked that you had to a considerable extent visually inhabited his space and made it, as he did, place. He would have appreciated the serial long-poem aspect of the sequence of images. So all in all he probably would have approved of the work. Is there any other visual record of Gloucester?

LS There are some compilations of historical photographs. Aaron Sisskind worked in Gloucester in the forties, but true to Sisskind's work the images are very much abstracted, close-up, and not necessarily to be identified with Gloucester. There are some photographers working in Gloucester now, but I've seen no large body of work.

SP Why would that be? First of all, it's an artists' colony, a tourist spot, a historical place. It was one of the first settlements on this continent; it has a history of over 350 years. You would think there would be some WPA project or other visual record of Gloucester. I was surprised when I went to the bookstores in Gloucester not to find any pictorial record of the chief landmarks of the city, and I wonder if there is a reason for that.

LS I don't know. But to go back to your earlier question, I hope that one of Olson's responses to the work would be that it was not commercial, didn't

pander, wasn't a cheap shot at the area. He felt very strongly about so many things going commercial. I certainly worked very hard to come up with serious, legitimate, thoughtful images.

SP One of the virtues of your work is light, a special sensitivity to the presence and uses of light. What do you think of the light in Gloucester? When Olson says, "Gloucester, the sky of Gloucester, the perfect bowl of land and sea," is he exaggerating?

LS I don't know. One of the painters, perhaps John Marin, claimed there was a special quality of light. But I don't know . . . the light's fine; it's perfectly adequate.

SP What are some qualities of light that a photographer must recognize and use? Light is obviously the agency of his work. What do you attend to in respect to light? What can light, certain kinds of light do for you?

LS The angle is a very important aspect. Low raking light tends to make a lot of buildings two-dimensional, because it only illuminates one face of them. If you look at a barn at sunrise, it looks like a Hollywood set—just that single surface sitting in a field. And low light will not illuminate the terrain much—just rake across it and pick up vertical objects. That's one kind of light. There's some of it in the early street scenes. It does marvelous things to clapboard and carving.

SP You're shooting right into the sun.

LS Sometimes, not always; there are different street scenes. But that light also gives dimension to a

city. The buildings have almost palpable shadows; you get more form and the light tends to fill up things— streets are a problem when you're photographing cities because they loom there, big, empty, you know, nothing, but if they have shadows in them. . . . There's a photograph in the series of two women walking down High Street, late in the summer afternoon, and they're casting shadows, and the houses are, and there's a lot of substance in the empty areas. Light does all of these things for you.

SP It fills space.

There's a landscape on page 107, *Maximus Poems*, Volume 3, December 22. A winter landscape. I remember that in speaking of photographing landscapes in winter you said that you could get the landforms through the trees—forms you wouldn't see when the trees are in leaf. Olson has such a landscape here. "The sea / is right up against the skin of the shore with a tide / as high / as this one, the rocks / stretched, Half Moon Beach / swallowed (to its bank), Shag Rock / now by itself / away from / the Island, [that's Ten Pound Island] the Island / itself a floating / cruiser or ironclad / Monitor, all laid out on top of the water, the whole / full landscape a / Buddhist / message, Japanese / Buddhism and maybe, / behind it, exactly in these tightened coves, Chinese / Buddhism, fullness and / pertinax, sharp-drawn / lesson, the rocks / melting / into the sea, the forests, / behind, transparent / from the light snow showing / lost rocks and hills / which one doesn't, ordinarily, / know, all the sea / calm and waiting, having come so far." Isn't that a remarkable poem? You have a comparable picture. It's the one of the marsh. . . . There are several long poems, a section on Ten Pound Island, Shag Rock. There's one a little later on. "Look at Ten Pound Is-

land all white except for the dusky old Light looking humpy and surely bedraggled like America since after the Civil War, when all is snowy roof-top's and light winter icing on Cup Cake Island, and High Tide exactly floating her in the Pan of the Harbor 7:35 AM And now—7:55 AM—Shag Rock is floating off by itself from the Island like an Eskimo Pie and WOW now the next morning it's a WHITE SHIP all floating by itself like a cake of ice."

LS Shag is connected at low tide. As the tide rises, it isolates it.

SP I was leafing through the *Maximus* thinking of what you said about people, and then I remembered that, living at Fort Square, he was very responsive to the women and to the people he lived among. "Contemplating my Neolithic / neighbors Mother and Son." Frontiero. Yes, and he has here very early in the poem . . .

LS They didn't get on so well . . .

SP No, this is "Mrs. Tarantino / occupying the yellow house / on fort constructed like / a blockhouse house said / You have a long nose, meaning / you stick it into every other person's / business, do you not? And I couldn't say. . . ."

LS I was walking around Fort Square and a woman in a yellow house stuck her head out the window and asked me what the hell I wanted. It may have been the same woman.

SP And then he has "When do poppies bloom," that incredible poem, "I asked myself, stopping again /

12

to look in Mrs. Frontiero's yard, beside her house on / this side from Birdseyes (or what was once Cunningham and Thompson's and is now O'Donnell-Usen's)." He is attentive to people although they figure less in his work than they do in yours.

Then there's a poem that gives us the total or circumambient landscape of Gloucester. "The Island, the River, the shore, / the Stage Heads, the land, it-self, / isolated, encased on three sides by / the sea and water / on the 4th side, Eastern Point an arm / such as Enyalion's to protect / the body from the onslaught of / too much and give Gloucester / occasion, give her Champlain's channel / in & out (as her river / refluxes), a body of land, hard on granite yet / arched by such skies favored by such sea and / sweetened in the air so briar-roses grow / right on her rock and at Brace's Cove kelp / redolents the air, jumps the condition and strain locus / falls or emerges as the rain on her or the sun." That's an ultimate landscape in his sense—an areal landscape, the total area of his world. What about places like Cole's Island and Lanesville and the Cut all the way over to the other side of Cape Ann? Are you going to follow up with anything on that?

LS I think so. I think the Annisquam and the Cut still hold a lot of material, but Lane's Cove at Lanesville no longer does. I probably photographed it at a propitious time because the big storm of '78 destroyed most of the granite seawalls there. I don't think they will get rebuilt. The Cut is an interesting photographic problem. There's that passionate poem (115–161 Maximus III), the one where Olson's up all night, and he's writing the poem and walking, and the Cut is such a powerful force, such a central feature, and he's sitting there, smoking, and the policeman comes by and it's hot in the summer and there's sheet lightning.

But to photograph it! It's another instance of the fact that in words it's a marvelous thing, but if you look at it, it's just fifty or sixty feet of water under a lift bridge and there's almost no place from which to photograph it, to show it with any interest.

SP The mythic sense of the relation of land and sea which is so central, the erotic significance it has . . .

LS The flow, the tide, there's nothing of that in still photography. I wrestled with the Cut, and I have a photograph of it; but it's not a striking image, and I don't know that there's anything striking to do with it.

SP Isn't the rest of the waterway behind the Cut, isn't the Annisquam, that whole marshy area, in its way exciting? Isn't there a photographer in England, by the name of Emerson, who did marshes . . . ?

LS Yes, people out hunting in the marshes and harvesting reeds . . .

SP I think that area, which is prominent finally, does have a part to play, would be visually rewarding.

LS You know the picture of the marsh and the mound is in that tidal area.

SP Oh, ah, yes, that's a great picture.

LS This area is physically difficult to penetrate. You almost have to photograph it from a boat. I haven't really finished dealing with it because one area, on the western side of the Annisquam River is marsh. On the eastern side it is mostly private housing

13

which comes down on the west side of Gloucester, east side of the river. You can't get to most of it because it's somebody's back yard . . .

SP What about other parts of Cape Ann and their accessability? How about Dogtown?

LS Well, Dogtown is hard to get to. It is a great big area, and it's not a national park, full of nice trails. Friends have taken me in, but the first time, I went in by myself and only found the Whale's Jaw. Some people in Gloucester tell you that the place is dangerous, thugs hang out there. There is an awful lot of disturbing random rifle practice and motorcycle riding.

SP That's where Babson . . .

LS That's where Babson put his "Study" and "Help Mother" and "Keep out of Debt." I forgot who told me, it may have been from reading Joe Garland, because those mottoes were carved in the Depression. Babson paid unemployed men to do honest work. Well, you come on them, there's nothing around them, just weeds, and you come on these funny things, "Never try / Never win" or "Industry" and there it is.

SP What about equipment, and the technical aspects of photography?

LS It seems to me that it's legitimate to deal with the technical. There's a middle ground between being coy and not saying anything, and in saying too much. The kind of thing that you get in some photographic magazines where the particular camera, the lens and the lens opening and the shutter speed and film used for a certain image are called out. That's unnecessary and is misleading, I think. It's meaningless.

SP Too much emphasis on technique.

LS It's the wrong knowledge about technique, because if somebody were to go back to the same place and use the identical equipment, film and exposure he probably would get a different result. There are too many other factors. But since photography is tied to technique, the equipment and things, one shouldn't be reluctant to talk about it. Most of the land- and cityscapes, seascapes, were taken with view cameras. I used two different ones.

SP Is there any special designation that would have meaning?

LS They are 4 x 5 view cameras. The lens I used most frequently was a 150 mm focal length which is a relatively short focal length, probably approximates a little more closely the way in which we see, with some of the peripheral view. I tended to use simpler and simpler equipment the longer I worked in Gloucester. For one thing, I began to appreciate the virtue of light weight because I was walking a lot, climbing around rocks. There really is a physical aspect to photography. You have to put your camera exactly where you want it to be. You can't approximate it, you can't cheat in any way, and if you're using a large camera it means tripod and camera. Sometimes you're perched in very precarious places. You've got the camera where you want it, but there's no place for you. You've got all those things to deal with. I started out using a fairly heavy metal camera and ended up using

a folding, wooden field camera—which is perfectly adequate and much easier to deal with. There are advantages in clarity and ability to render textures inherent in a larger negative. It packs more information in; you don't enlarge it as much to make a comparable size print.

But I think we all know that photographing people unposed is best done with a hand camera; usually a 35 mm. You can move quickly with it, you don't need a tripod, you can focus quickly, it has a very fast lens so you can work in dim light.

SP Would the use of the 35 mm camera be close to the way Jonas Mekas talks about using the movie camera as an extension of his perceptual system? Wouldn't that be close to what a poet does writing poetry, enacting, literally, his awareness in the process of writing poetry and taking those risks, as against the 4 x 5 camera with which, because of the stability of the camera and the cloth you put over your head, you can literally previsualize or at least see your composition on the ground glass? There are two different kinds of risks involved, or two different kinds of composition involved.

LS That's right. With the 35 mm a lot of what you do is unconscious. You work very quickly, you may be paying attention to a central subject, and if good things happen in the background, or in related areas, it's probably because your subconscious was at work. If you're very familiar with a camera you're not even aware of using it; it's almost an extension of your eye. You make the adjustments without much thought; you work quickly. But the other point I want to make: There are other instances where 35 mm will yield a superior photograph. For example, I did quite a few

things, minutiae on the beach, seaweed, feathers, things like that, things that were mostly in the sand. I tried to do this with a large camera. One would think that something with a lot of texture would be an ideal subject for a large camera, but the difficulties of working in wet sand—and a lot of it was in the tidal area, tripod sinking in, trying to work with a very large camera with something very small so the camera itself shades the image and is awkward to deal with, you almost need a ladder because you're pointing straight down and you can't see the ground glass—it turns out you can get a better final image with a 35 mm camera because you can get down on your knees, you can move when the tide comes in. You have to suit the equipment to the occasion.

SP That so many of the photographs are the product of the view camera, of the heavier, larger equipment, does that account for what might be called, literally, the stillness of so many of the photographs? Or is that a product of your vision? One of the things that distinguishes your visual vision of Gloucester from Olson's verbal vision is that the verbal vision incorporates a sense of energy and the sense of a living world in the very texture of the language, whereas although there are some photographs that capture the dynamism and the energies of the environment, most of them are notable for their stillness. That's one of the qualities that define these photographs, in part, because you took so many early in the morning, when the water was still or the sky was overcast or quiet. I am thinking too of stillness in respect to Fitz Hugh Lane whose pictures have an arrested quality, and that's one of the things that Olson, when he's talking about what Lane didn't do, wants to do; to capture the dynamic quality of this environment.

What Lane did was arrest it and find those very quiet moments which were the visual equivalents of the spirituality that he had discovered in transcendentalism. The stillness in your photographs, I don't think, necessarily, has that spiritual reference. Am I right?

LS Yes, if they are still, it's not because I'm a transcendentalist. But it's inherent in the way I view things. It's not consciously imposed. It is also a fact of life that it's hard to take photographs in bad weather. You can't work with a large camera in a windstorm, you can barely work with a small camera, and it is very difficult to take pictures in the rain because it ruins the equipment or gets all over the lens. Also, the stillness in the Gloucester pictures was, in part, imposed on me. In all the times I was there, I never found the sea running heavily. That's just a quirk.

SP Some of these photographs, you know, appeal to me immensely. There's one here, a late winter scene without snow of the marsh and the hill in the background. The foreground is the dried grass of the marsh, and there is very still mirrorlike water, a body of water to the left, and then this low concave hill with the leafless trees and brush of late winter. A very subdued photograph visually, the tonalities are all quiet—well, I'm actually reading the photograph, when I wanted you to read the photograph. It has for me a quality, I don't know that you want to call it mystical, but it has some of that depth, that dimension we were talking about earlier, has it in unusual degree. Would you like to talk about the photograph?

LS I don't know whether it's because of Indian mounds or whether the mound shape in other cultures, too, has signified a place where something happened or something was buried, but I sensed the singularity of this shape in the landscape, in that part of Gloucester, anyway. It hovers there, and particularly at a time of year when everything is muted. The foreground grasses, I thought their texture and their intricacy, the matlike quality—delighted in that textural area and the leading up to this somber moundlike form in the background, and the reflection of part of the mound. I liked the way it all played together. It's a case of putting together the shapes that appeal to you. I had seen the mound several times before, but because of the barren quality this was the time of year when it was best to photograph it.

SP It's a very erotic shape. I was almost led to speak of certain parts of the body. There are others among the many photographs that especially appeal to me. The one near Stage Fort: the great outcroppings of granite, then the marshy texture of the foreground and the quiet sea almost indistinguishable from the overcast sky, and the trees seeming almost to be Japanese or miniature trees silhouetted against the grayness. This, again, has a kind of mystical quiet for me, partly because of the way the sea runs into the sky. It evokes harshness, the physical difficulties of that environment, and the immensity of the granitic structure of Cape Ann and the tenuousness and tenacity, too, with which these trees, these very small trees, have secured themselves on this rocky outcrop. A visual fable of the planting.

LS This photograph illustrates some of the things we've talked about before. One, that the classic good day to take photographs is not necessarily the day with blue sky and white puffy clouds, and a bright sun. I think that would have destroyed what I felt was the strength—the land and rock form. This also illustrates one of the virtues of going back and going

back. I had photographed many things in this area earlier, almost in the way an artist does sketches. I had a 35 mm camera. I found the forms appealing, took photographs, and realized that a 35 mm camera would not do justice to the texture of the rocks or the grass or the expanse of sky. You can't render them as smoothly or show the texture with such fidelity. So I came back, in fact I came back with my work prints in hand in order to find the same areas, and set up with a big camera. The lobster fisherman in the boat was just a happy accident.

SP And then there's the one on the other side of Gloucester—is it Good Harbor Beach, taken at night, one of your night photographs, apparently looking across Eastern Neck to the lights of the city beyond?

LS Yes, looking southwest.

SP Then the intervening landform would be the great arm that goes out into the sea and what we see beyond is Gloucester.

LS Yes, to your left is Atlantic Avenue.

SP It seems that the tide is withdrawing and you have lovely shades of dark.

LS Look at that carefully. The thing that took me aback at dusk. . . . I noticed something new to me, that at dusk, with a fairly bright sky, you get a reversal of the usual tonality in the waves. The thing about waves in the daytime, the leading edge is full of bubbles and it's white, and the water that follows it coming in on the beach is dark, reflecting the blue sky. At night, the bubbles don't catch light so they go dark and the water goes light—an exact reversal of the way in which you see waves coming in in the daytime.

SP And that light in the waves plays off against that very quiet glow in the sky that is the afterglow of the setting sun because we're looking west. It's not the glow of city lights against the clouds; it's more natural, it's obviously the source itself. We're looking at it in the distance, but it is also present to us as the source that's creating the light that's emanating from the receding water. So there is a connection between sky and water which is absolutely lovely, which again gives this photograph an epiphanic quality.

LS It could have been taken without showing Gloucester. In a number of photographs, because of the spirit of the project, I've tried to include an object, in this case a view of the city, that tied what I was photographing to Gloucester. Otherwise it could be just a beach anywhere. There was more challenge and legitimacy in the spirit of this project since I was always trying to tie in what I was photographing with Gloucester.

SP Is that what you were talking about earlier: a kind of focal point for the whole series? To have always that point of identification for any view, so when we talked about this photograph we immediately tried to locate it geographically? We were forced to go to the map and say, "This is on the Atlantic side" and "We're looking in this direction"; we were trying to orient ourselves—and that's as it should be because Olson is a map man, and intends for us to know a geography in terms of charts and maps and always to locate ourselves, "fix" ourselves.

LS Well, with the exception of close-ups, which

lose their location, most of the photographs can be identified by a street, a house, something in the background. It was intentional that you could always see, yes, this is part of the Gloucester landscape. That was a thread in the whole series.

SP One final question one always asks about photography, and that has to do with the word *image*. You could call these photographs images of Gloucester; images in the double sense that an image is a correlative of a thing, in that sense objective; and you could also speak of them as your images, by which one would mean that they are your vision of Gloucester, your perception, your projection, so that's subjective. And the interesting thing in the photographs, it seems to me, is the balance between these, the documentary and the expressive. To what extent are the pictures "faithful" to Gloucester, and to what extent is this Swigart's Gloucester? Or maybe the question is to what extent is this Olson's Gloucester.

LS You're opening up a huge issue with this single question.

SP I know, but what I've been pondering all this time is the question anyone who opens this book of pictures will want to ask: How do you characterize

this man's work? And I think to answer that question is to speak about a particular blend. If I should answer the question, I'd say, yes, these pictures can be used in a large way, simply as document. And yet, as a total canvass of the environment, because of the kind of selection you make and the kind of camera work you do, they are *your* Gloucester, and they have *your* values. It seems to me that they come closer to being Olson's Gloucester in having a quality of intimacy. Your landscapes—Dogtown, the ocean, the lonely beaches, whatever—your landscapes are habitable, benign, even the winter scenes; and I think this vision is a correlative of the other characteristic that I find in your work, that is, its clarity and care. In many ways you would be considered a "classic" photographer, particularly in the care with which you compose and the clarity with which you present your images. I'm trying to fit you in the spectrum of photography, and I think that that's the character of the work, the care and the unusual quality of light and the sensitivity to physiographical form. And where it becomes Olsonian—indeed, where it comes close to postmodern poetics—is in its eroticizing of the landscape. The shapes that you've emphasized in the landscape are very erotic shapes. That's what makes the landscapes habitable—fill space—and that's especially where I see a connection with Olson.

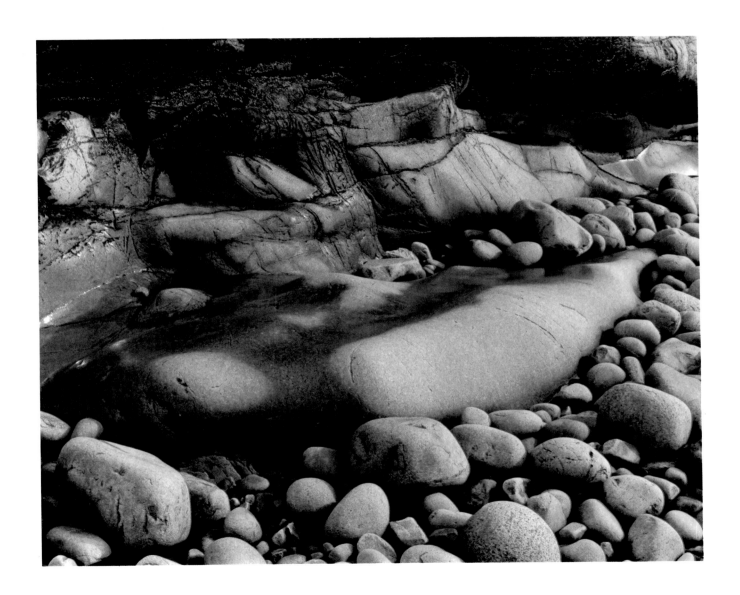

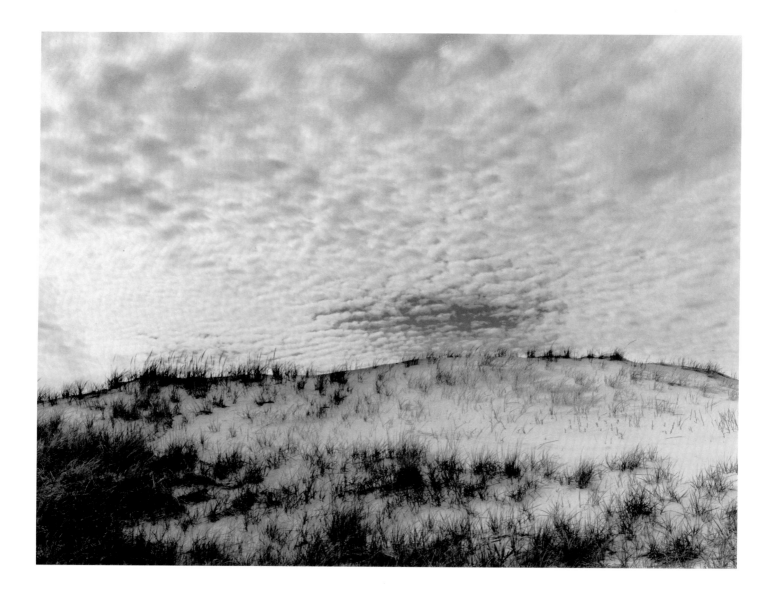

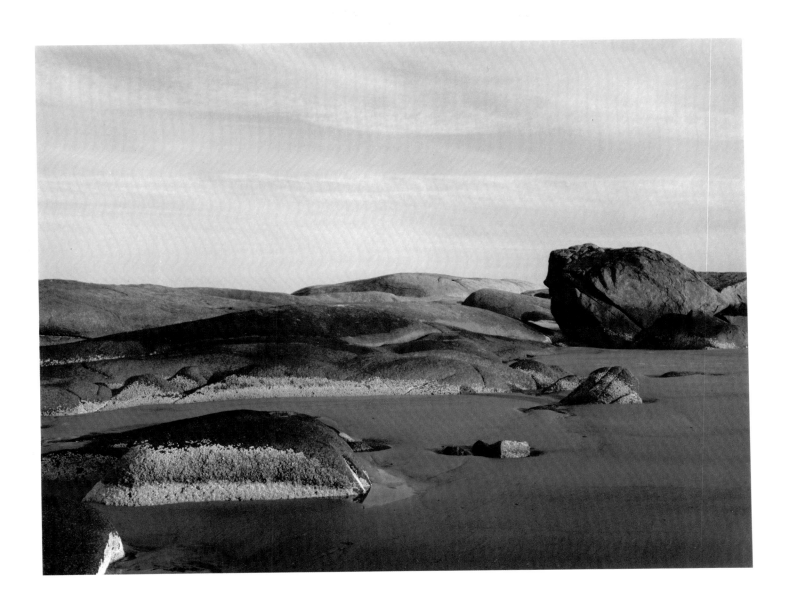

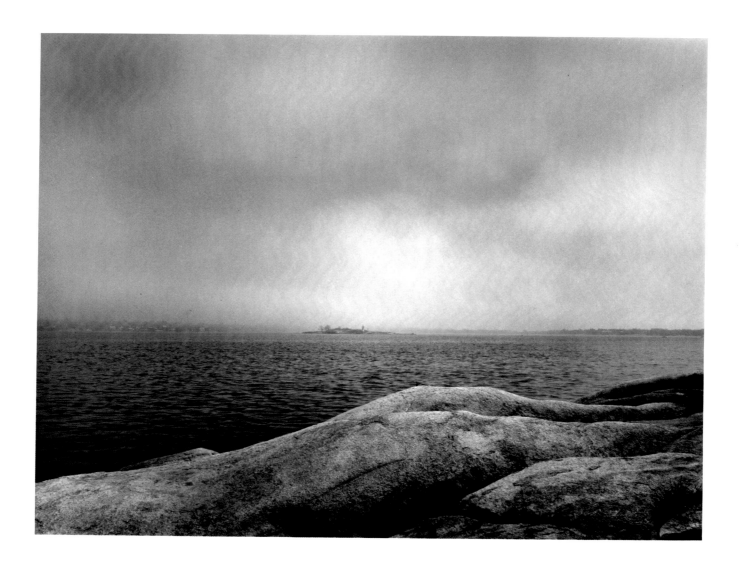

22

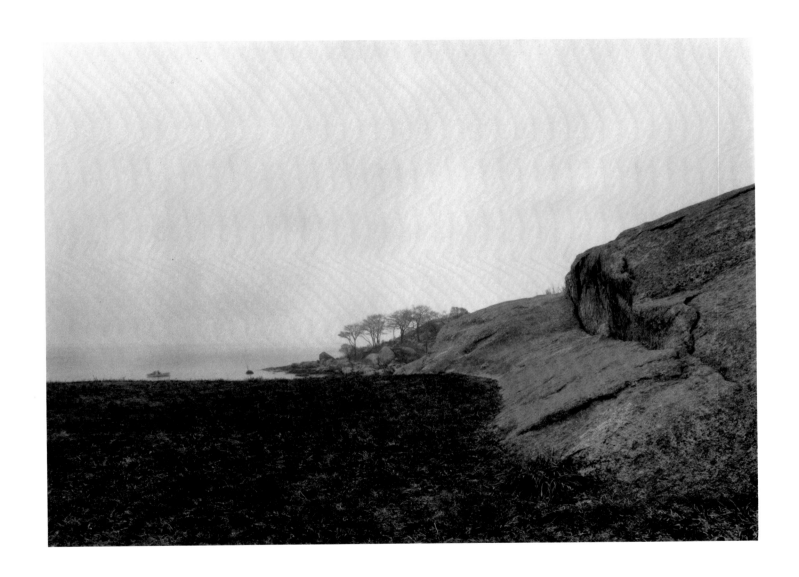

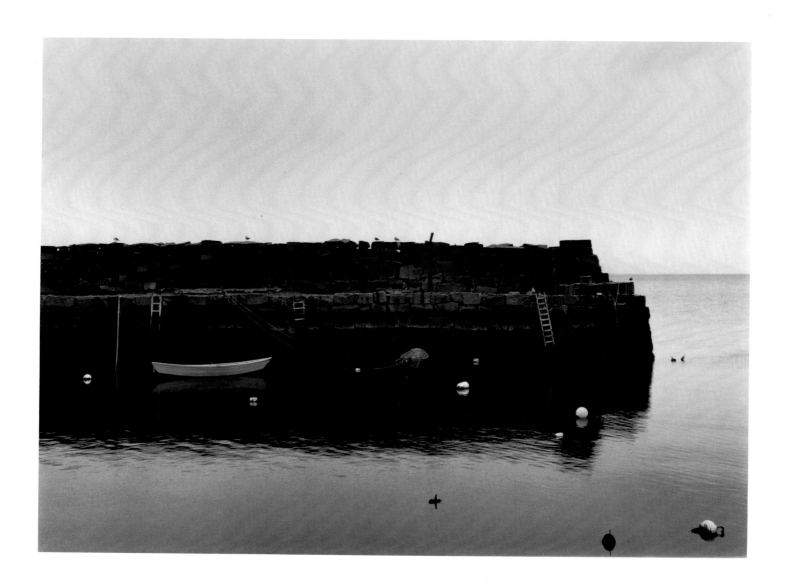

24

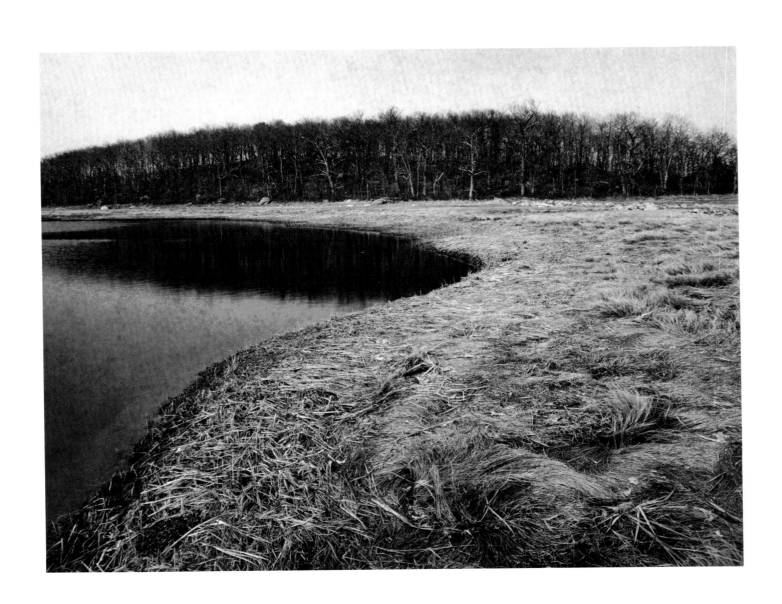

Only my written word

I've sacrificed every thing, including sex and woman
—or lost them—to this attempt to acquire complete
concentration. (The con-
ventual.) "robe and bread"
not worry or have to worry about
either

Half Moon beach ("the arms of her")
my balls rich as Buddha's
sitting in her like the Padma
—and Gloucester, foreshortened
in front of me. It is not I,
even if the life appeared
biographical. The only interestingj thing
is if one can be
an image
of man, "The nobleness, and the arete."

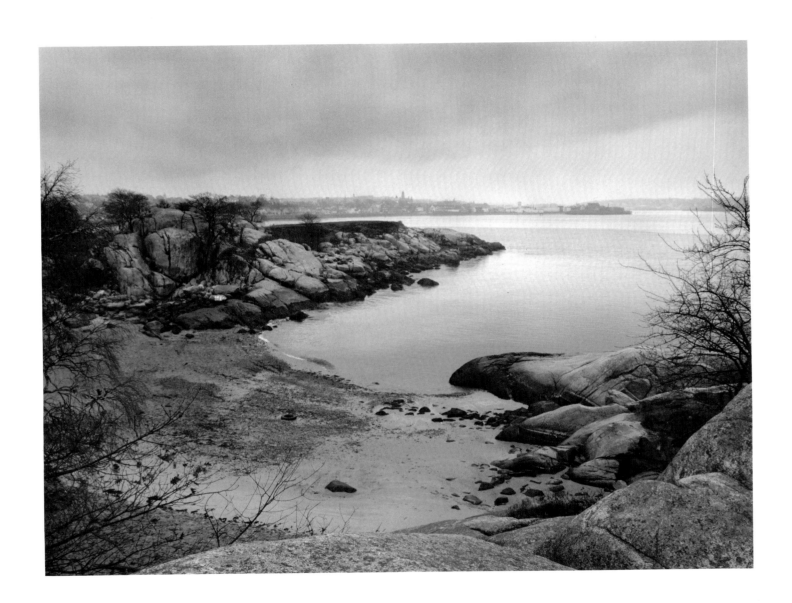

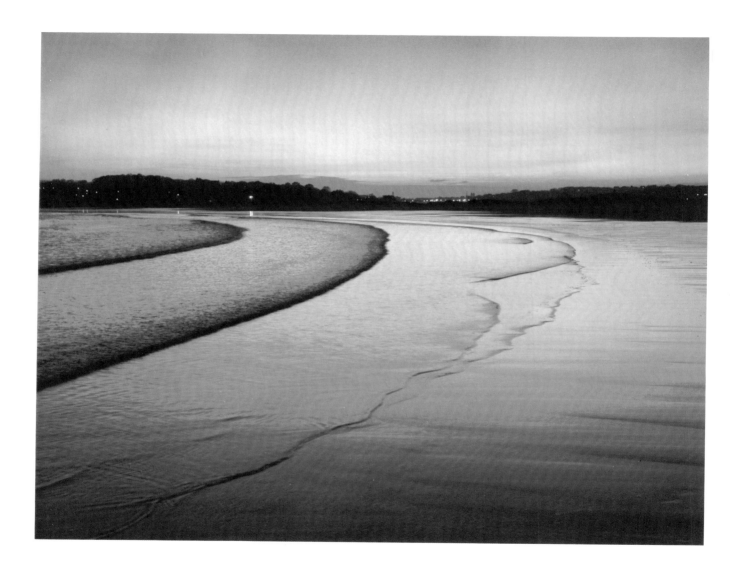

28

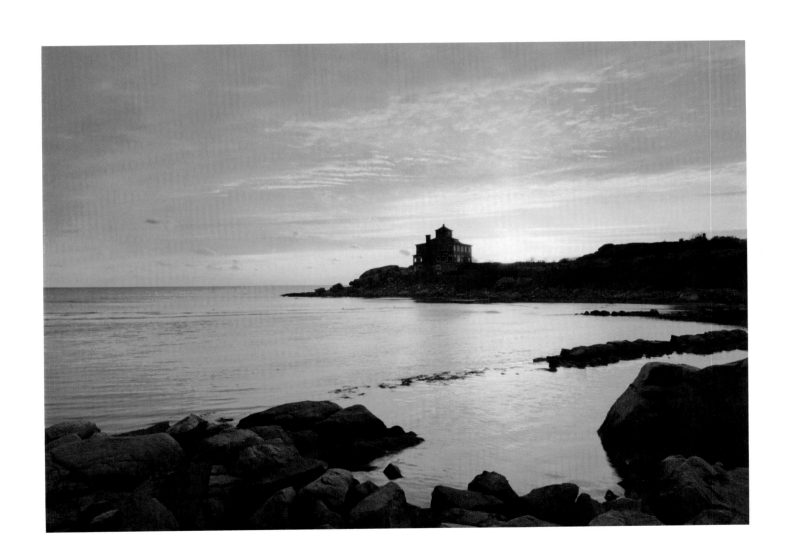

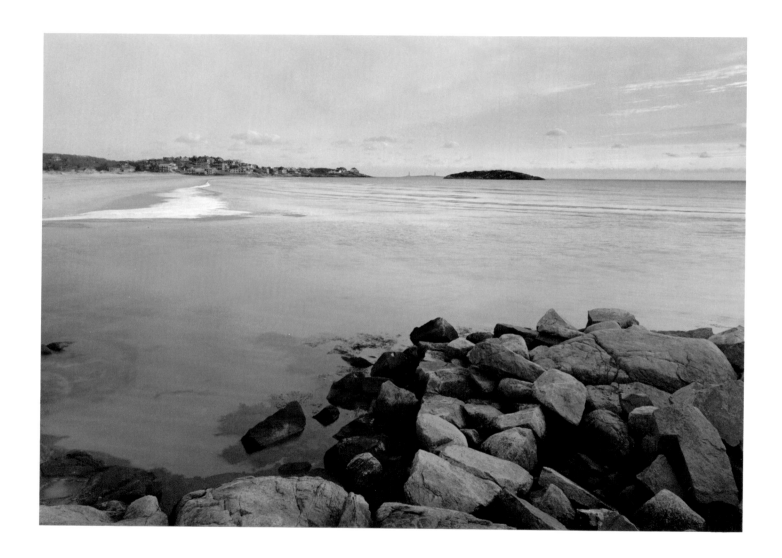

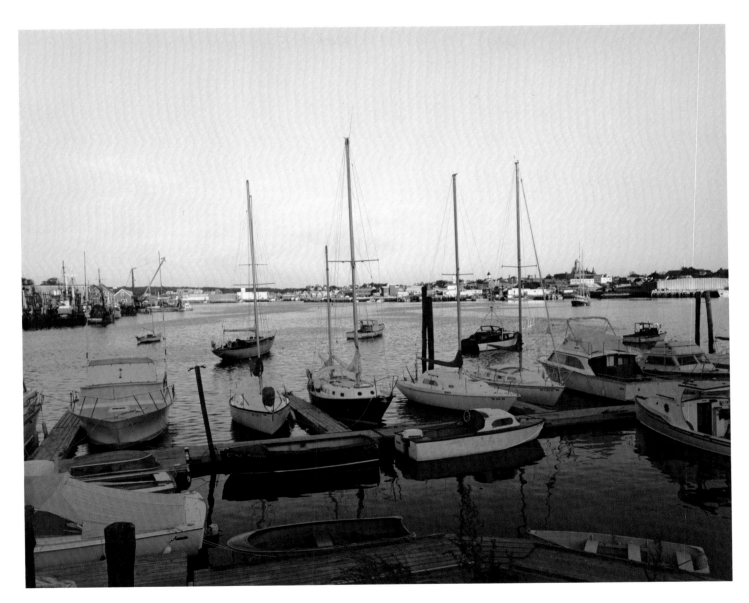

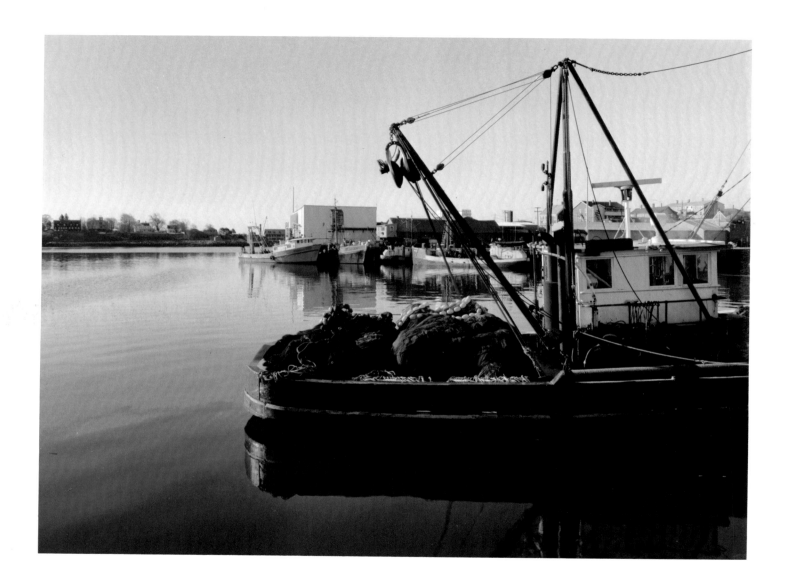

32

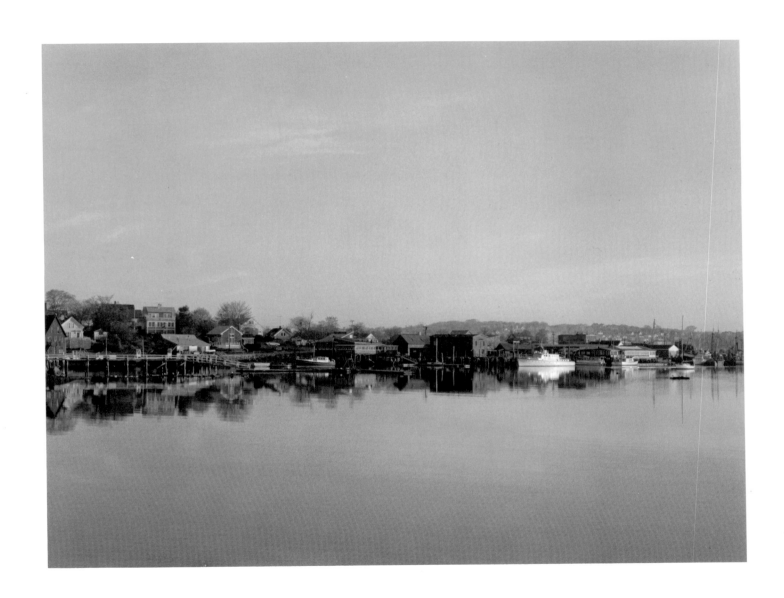

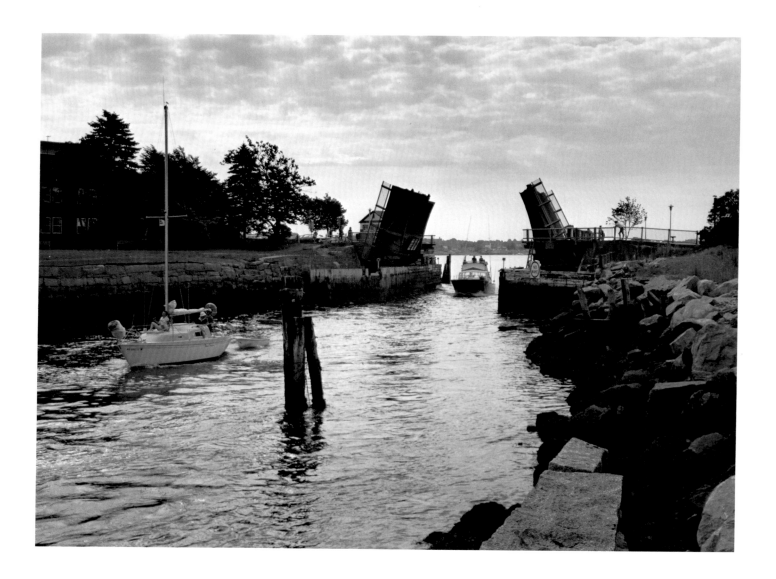

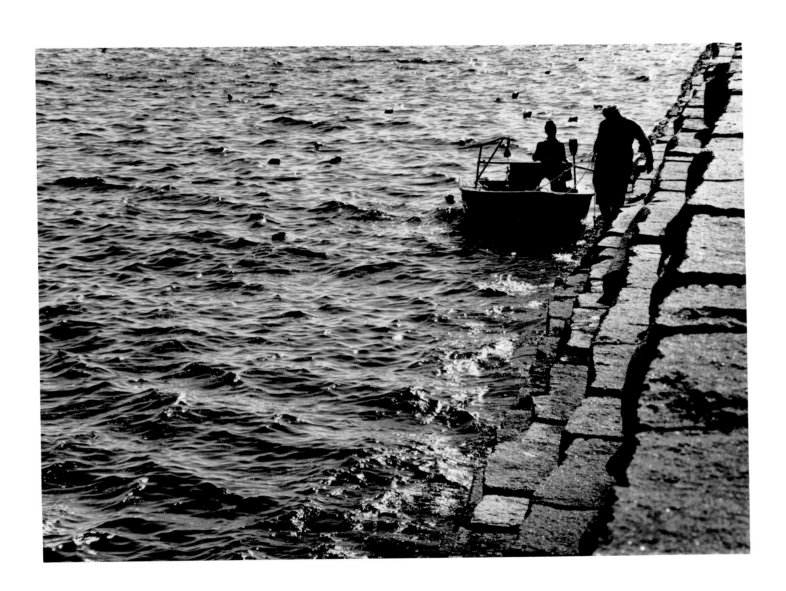

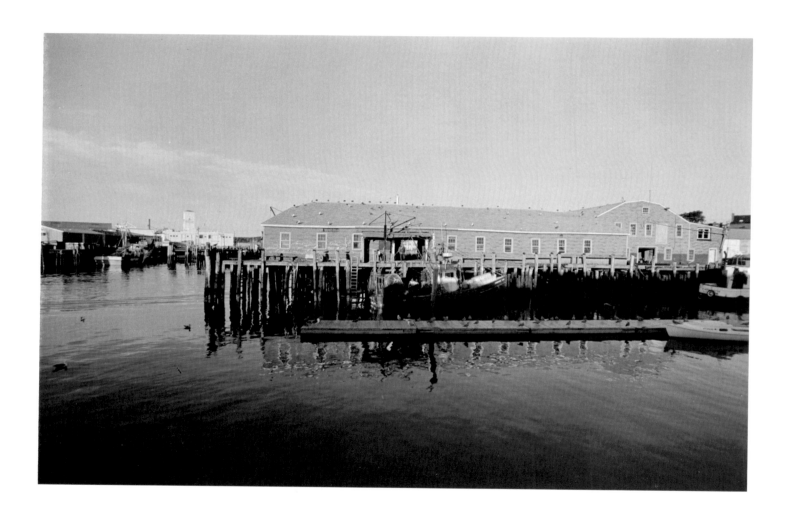

36

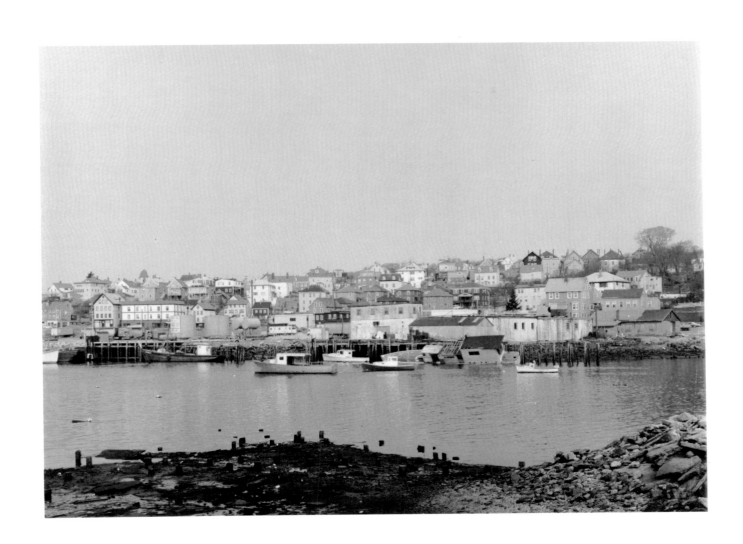

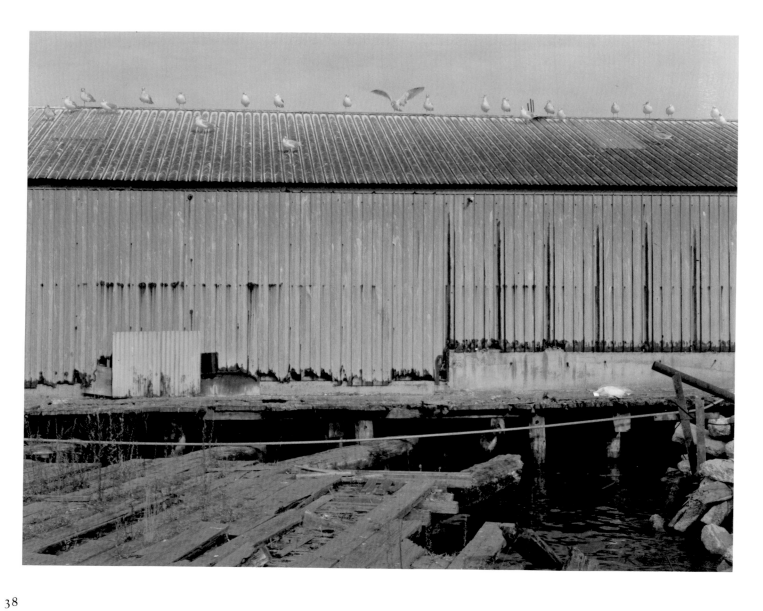

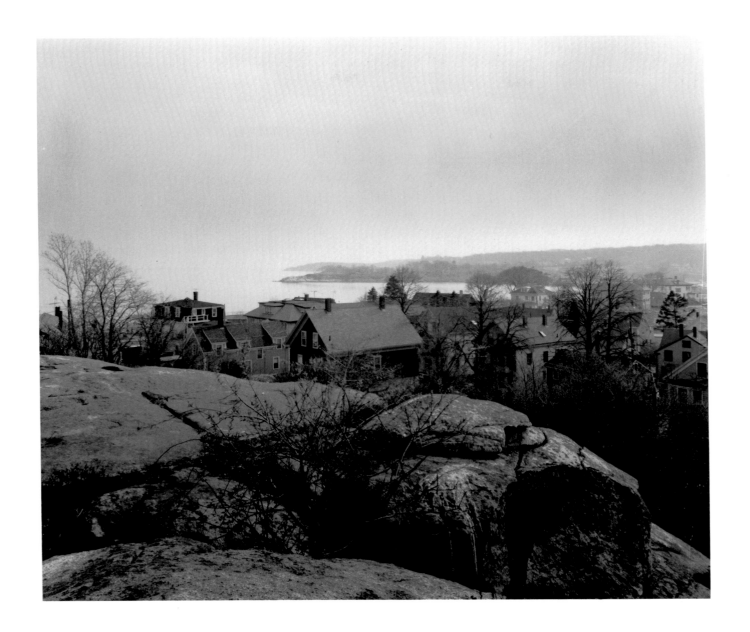

39

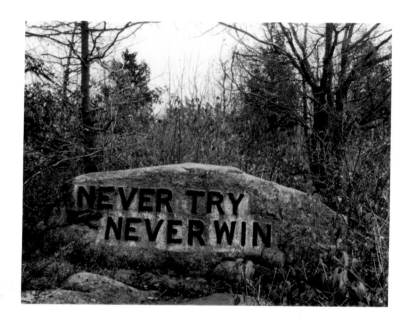

(*Later*: myself (like my father, in the picture, a
 shadow)
on the rock
There is this rock breaches
the earth: the Whale's Jaw
my father stood inside of

I have a photograph, him
a smiling Jonah forcing back those teeth
Or more Jehovah, he looks that strong
he could have split the rock
as it is split, and not
as Marsden Hartley painted it
so it's a canvas glove

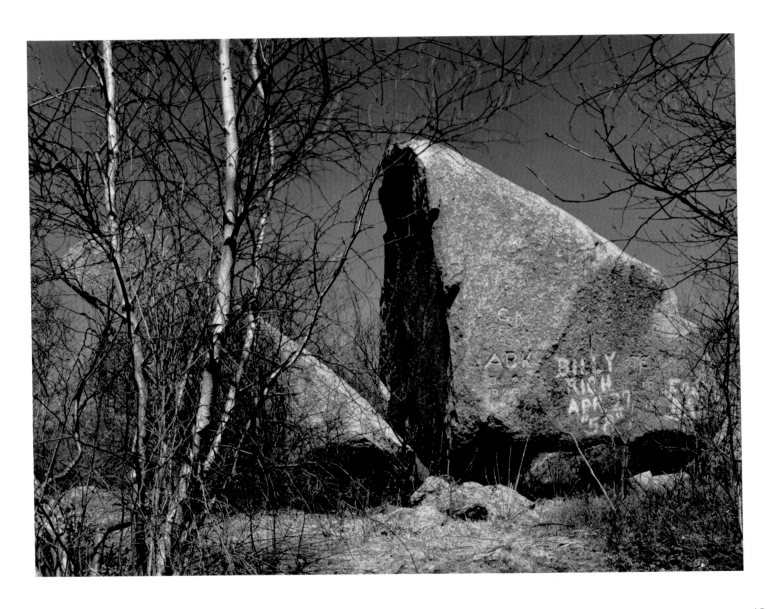

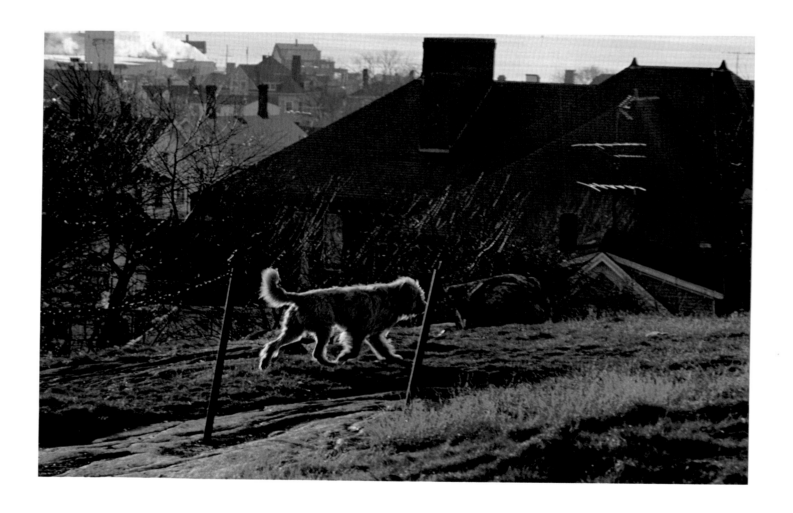

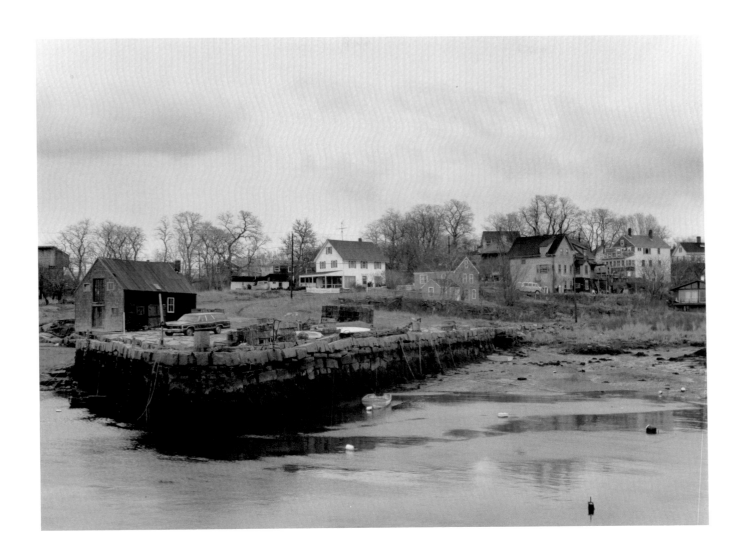

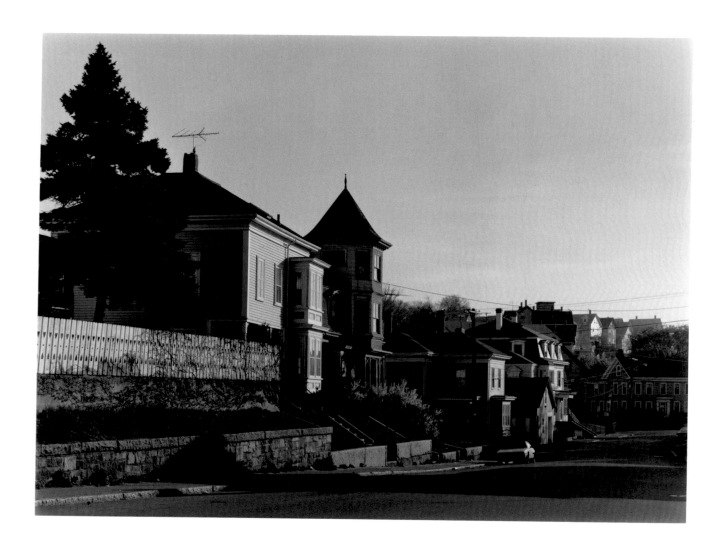

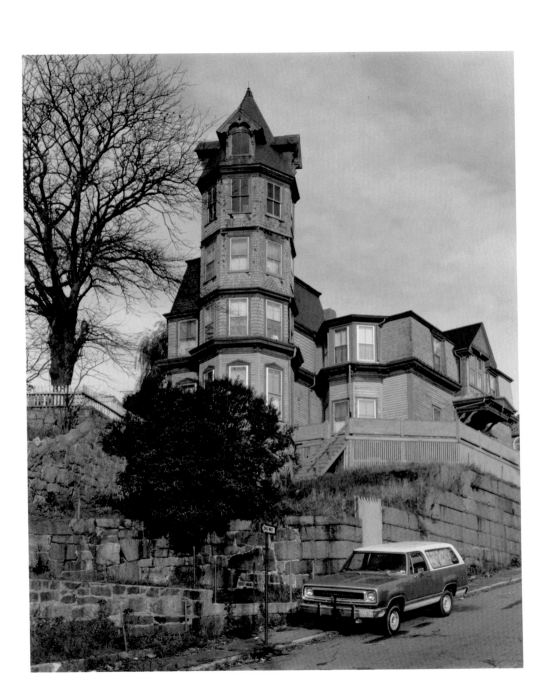

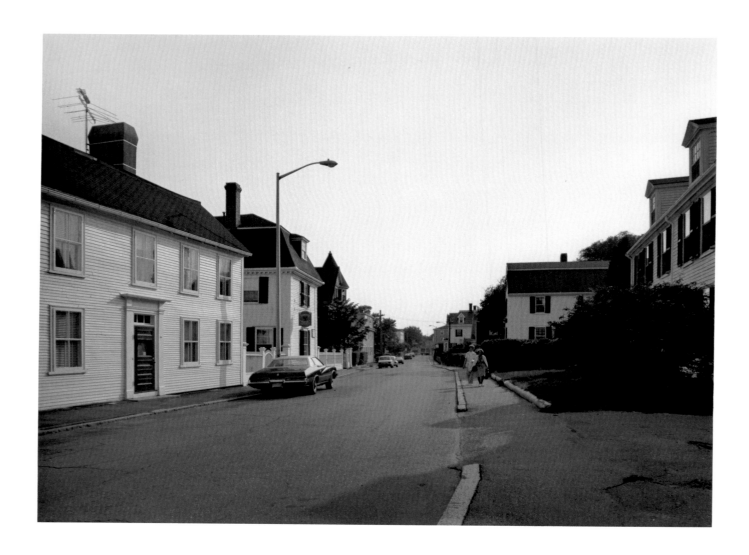

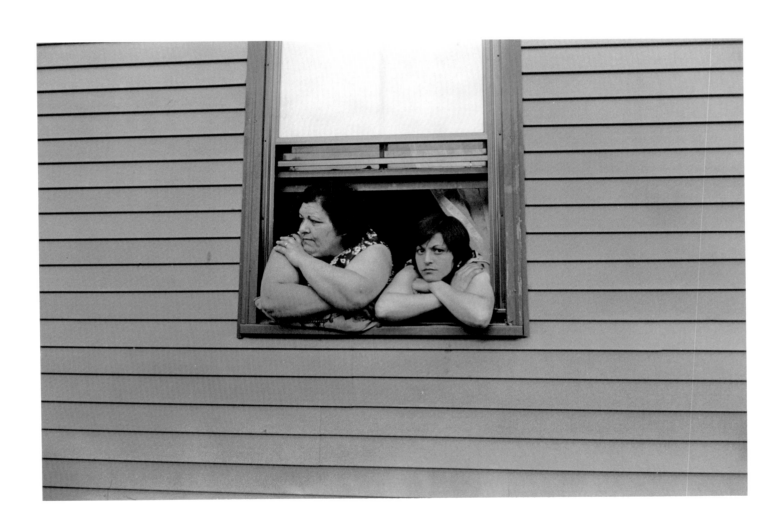

the light, there, at the corner (because of the big elm
and the reflecting houses) winter or summer stays
as it was when they lived there, in the house the
 street cuts off
as though it were a fault,
the side's so sheer

they hid, or tried to hide, the fact the cargo their ships
 brought back
was black (the Library, too, possibly so founded). The
 point jis

the light does go one way toward the post office,
and quite another way down to Main Street. Nor is
 that all:

coming from the sea, up Middle, it is more white,
 very white
as it passes the grey of the Unitarian church. But at
 Pleasant Street,
it is abruptly
black

(hidden
city

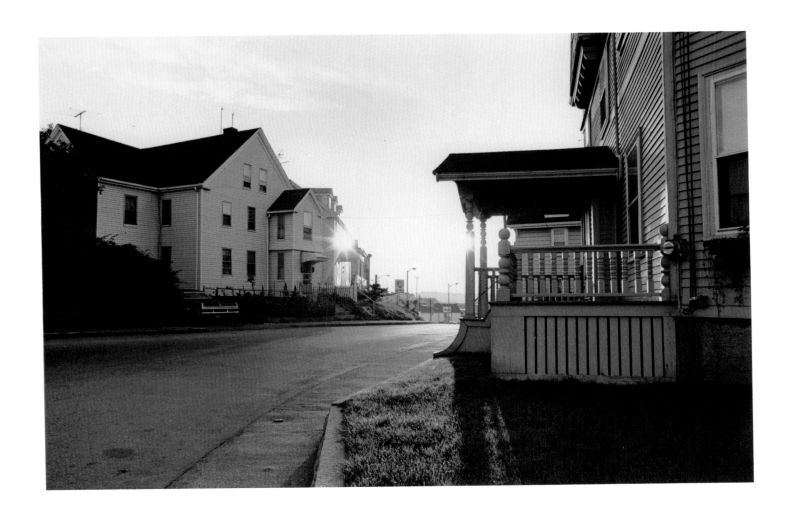

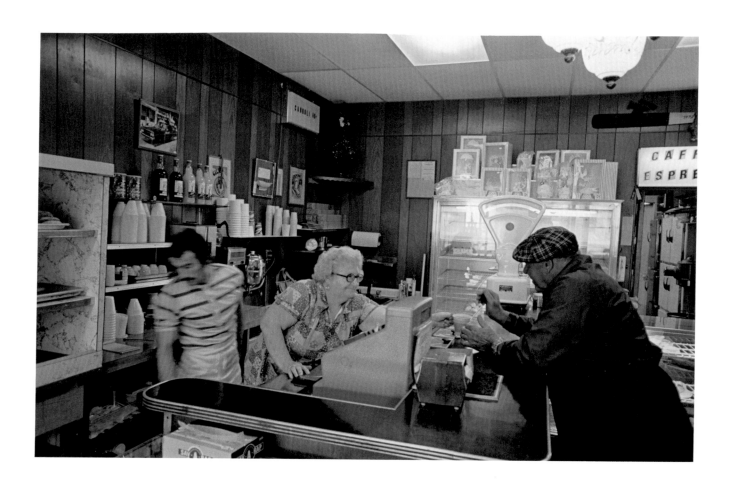

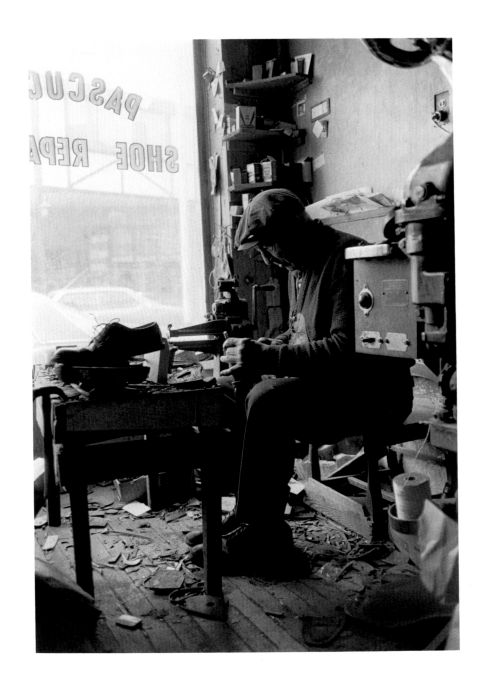

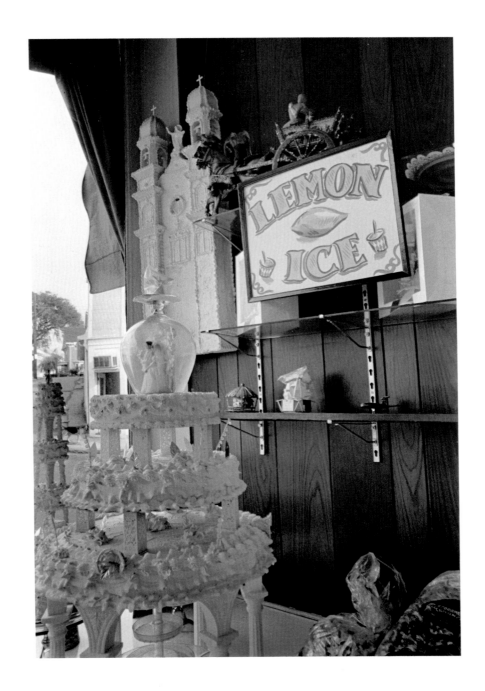

53

(o my lady of good voyage
 in whose arm, whose left arm rests
no boy but a carefully carved wood, a painted face a
 schooner!
a delicate mast, as bow-sprit for

 forwarding

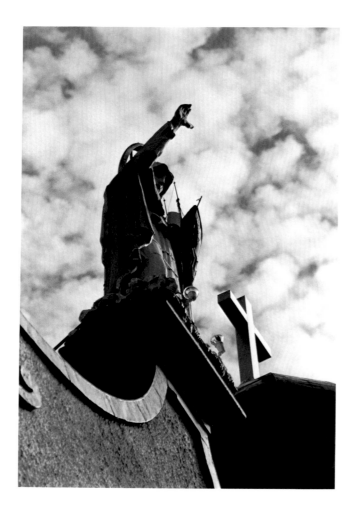

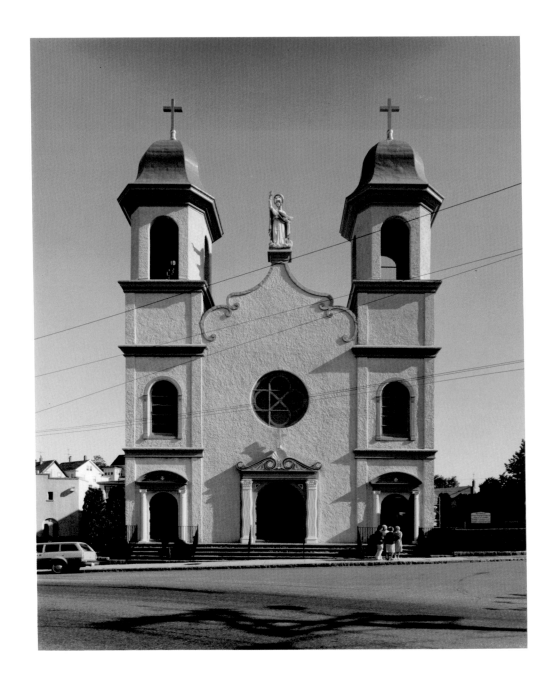

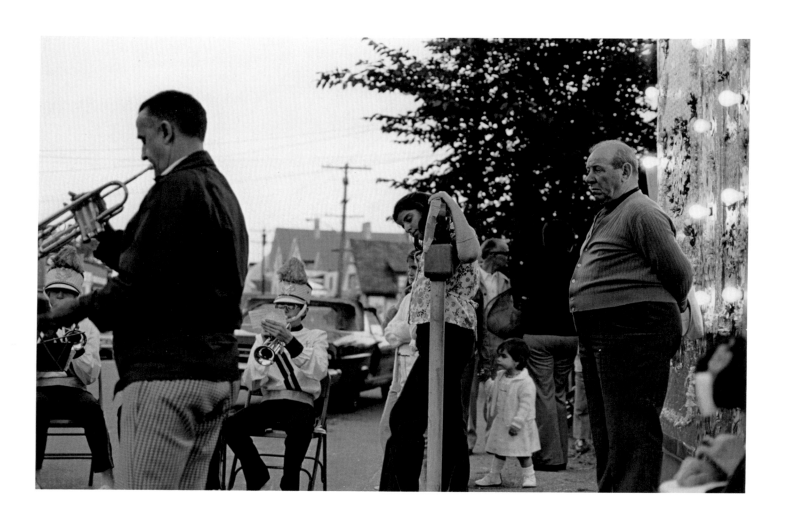

56

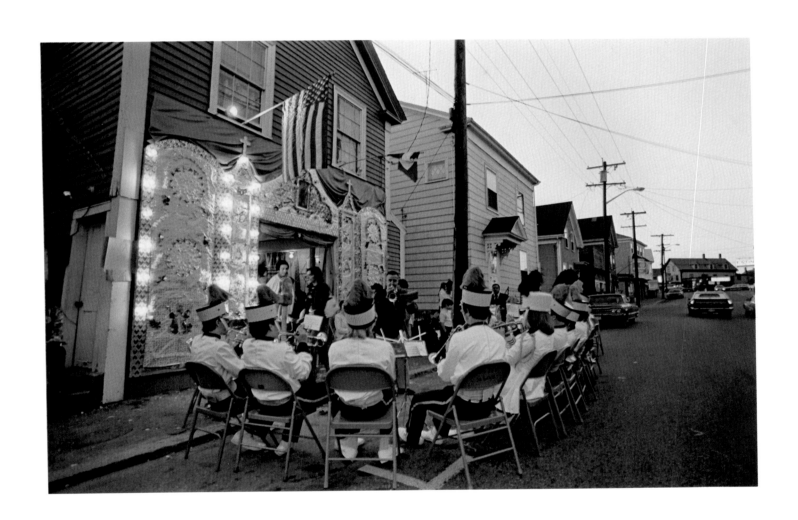

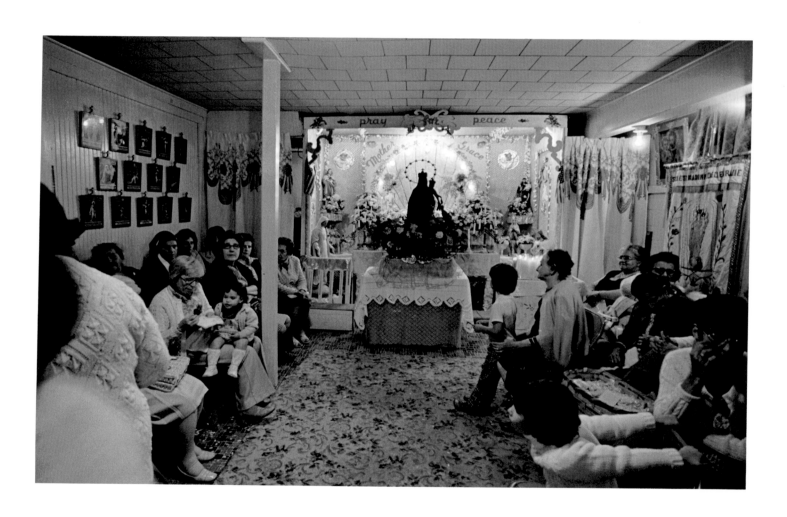

58

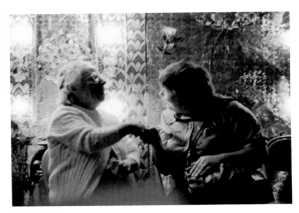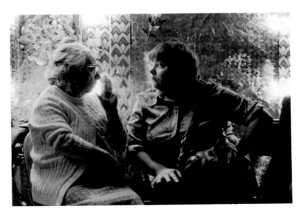

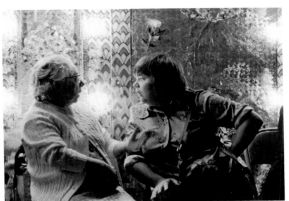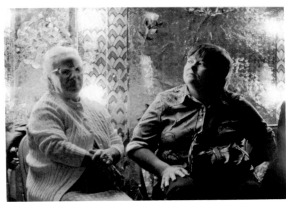

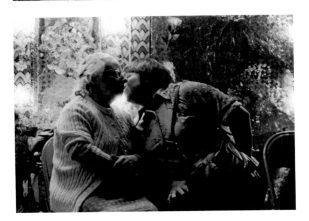

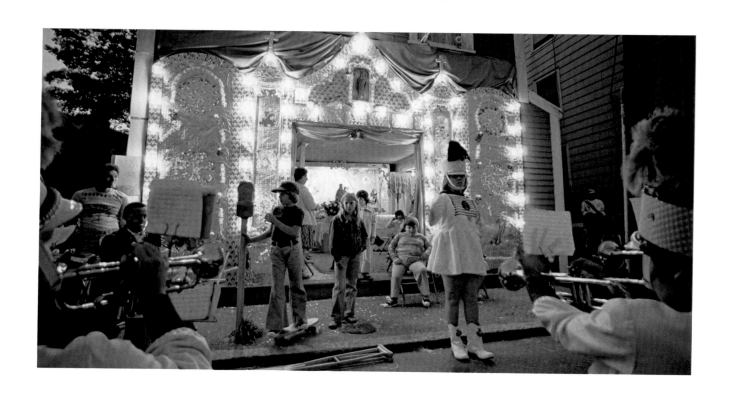

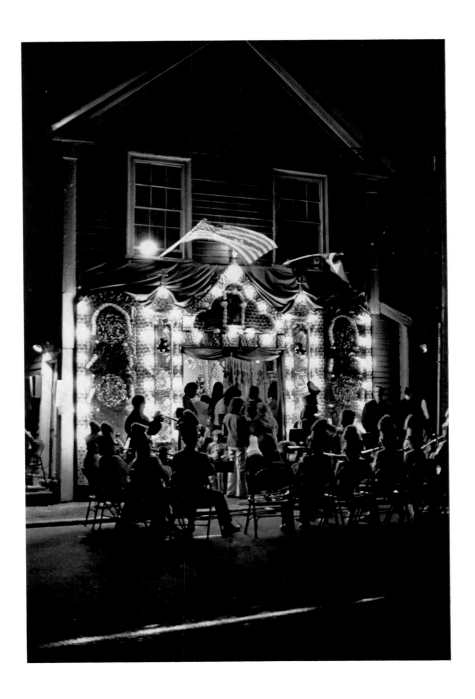

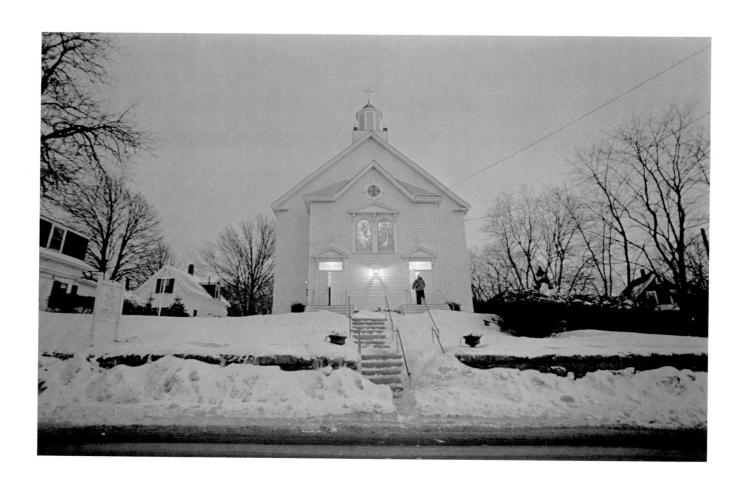

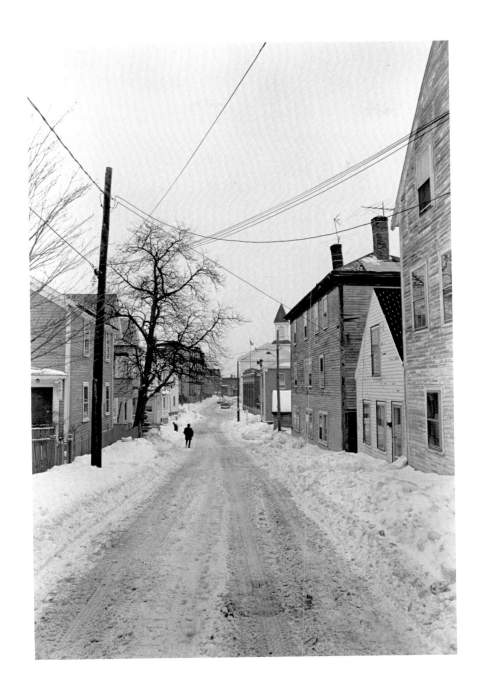

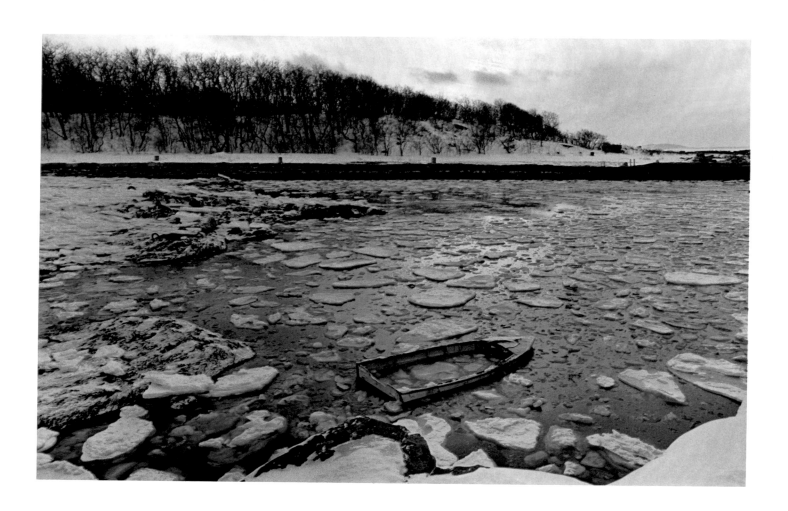

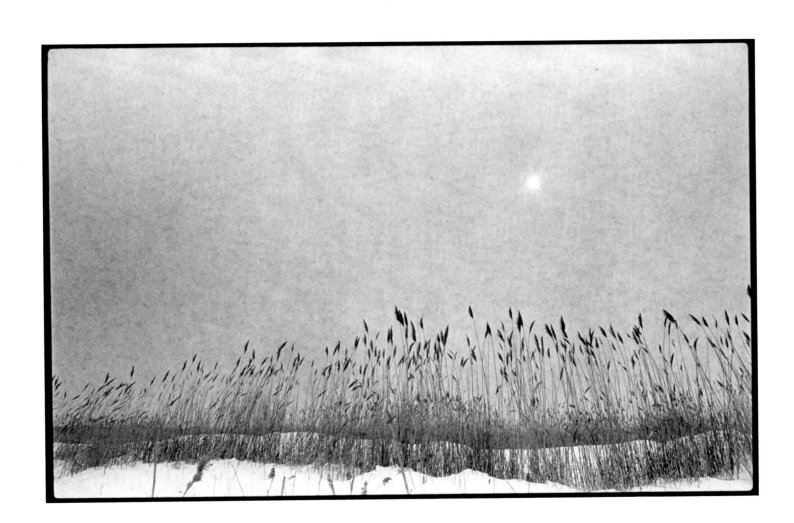

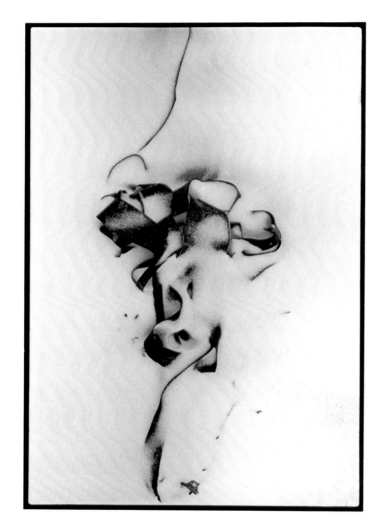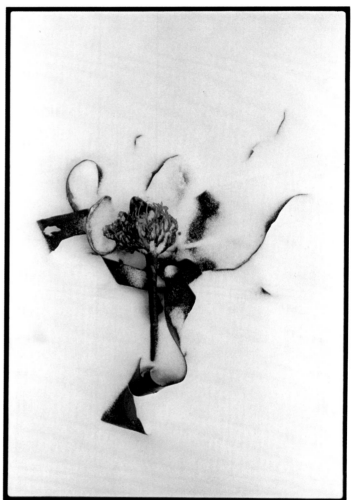

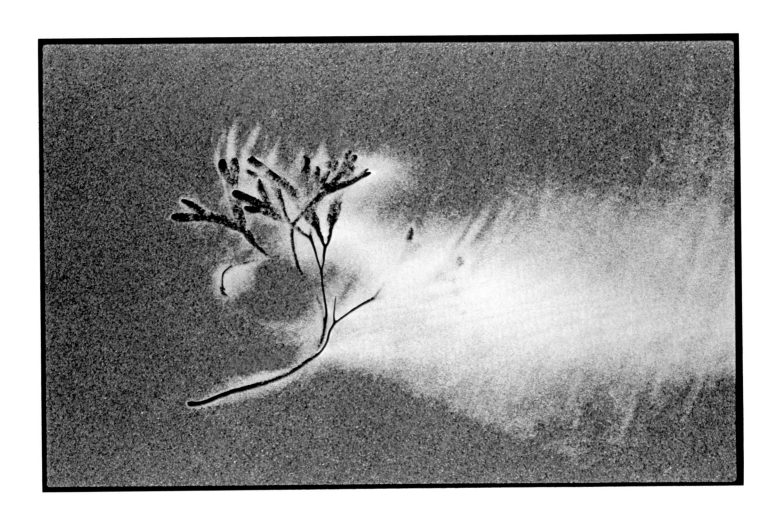

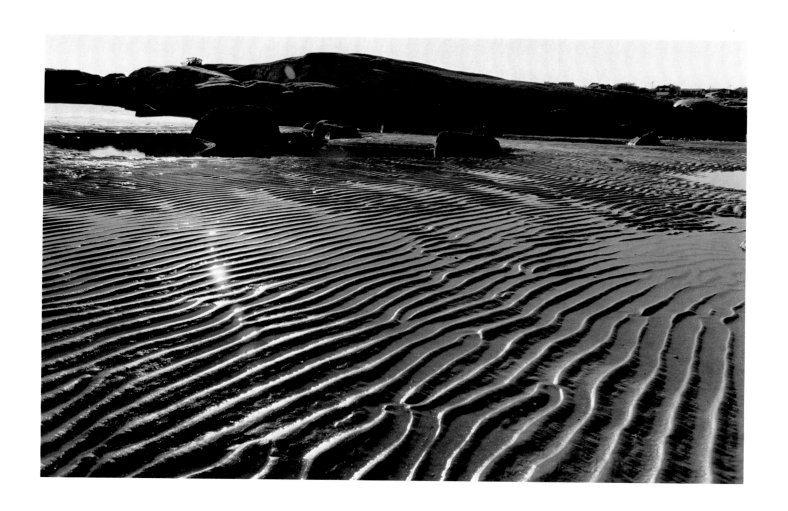

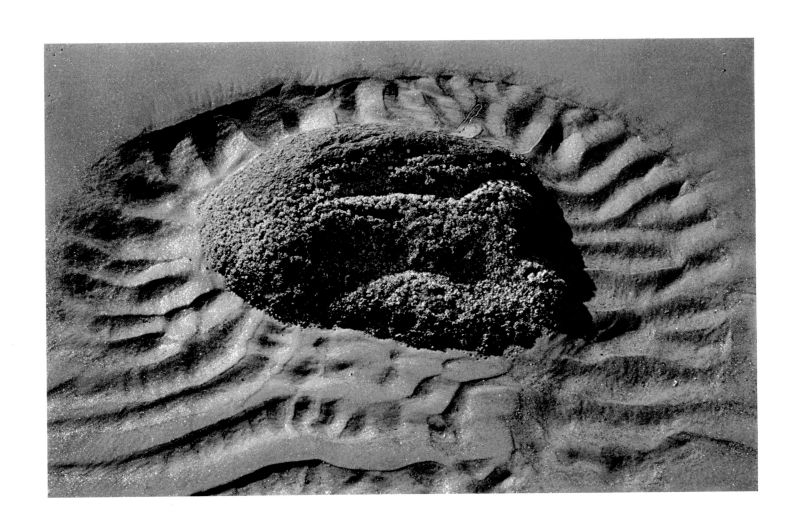

Notes on the Photographs